IMAGES
of America

ANACORTES

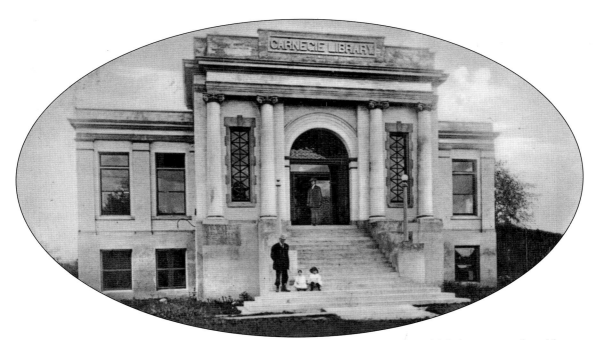

The Anacortes Museum is located at the corner of Eighth Street and M Avenue in the old Carnegie Library. Local citizens were awarded a $10,000 grant from industrialist Andrew Carnegie in 1909 to build the library, which for decades served as a center of the community's academic and social life. The Anacortes Museum has continued this tradition since moving here in 1968. Other Anacortes Museum facilities include the steam-powered snagboat *W. T. Preston* and the Snagboat Heritage Center at 713 R Avenue. (Courtesy of Anacortes Museum.)

ON THE COVER: These members of the Elks Club are dressed in costumes to celebrate Independence Day in 1911. Behind them is the Hotel Taylor, which was built in 1890 on the west side of Commercial Avenue between Railroad and Second Streets. The local Elks Lodge 1204 was granted its charter on June 25, 1910, with 100 charter members and has occupied several locations throughout more than a century in Anacortes. (Courtesy of Anacortes Museum's Wallie Funk Collection.)

IMAGES
of America

ANACORTES

Bret Lunsford

ARCADIA
PUBLISHING

Published by Arcadia Publishing
Charleston, South Carolina

Printed in the United States of America

Library of Congress Control Number: 2008940084

For all general information contact Arcadia Publishing at:
Telephone 843-853-2070
Fax 843-853-0044
E-mail sales@arcadiapublishing.com
For customer service and orders:
Toll-Free 1-888-313-2665

Visit us on the Internet at www.arcadiapublishing.com

To my daughters and the next generation of Anacortes history lovers

CONTENTS

ACKNOWLEDGMENTS

Love of history is alive in Anacortes thanks to the pride our community feels about its past. The Anacortes Museum has encouraged a participation in history through ongoing lectures, book publication, and video documentary production and by ably responding to research requests for academic and genealogical projects.

Most of the photographs in this book are from the Anacortes Museum and specifically the Wallie Funk Collection. As publisher, editor, and photographer at the *Anacortes American*, Funk led a crusade for historic preservation that resulted in the creation of the Anacortes Museum. His donation of thousands of photographic images (including the Ferd Brady Collection) and bound editions of the town's newspapers form the museum's core. I have benefited from Wallie's passion for and knowledge of local history. I am grateful to the staff of the Anacortes Museum for allowing me access to the photographs and research catalogs: director Steve Oakley, curator Judy Hakins, registrar Evelyn Adams, educator Terry Slotemaker, and also museum aides Pam Bagnall and Kay Glade. The Samish Indian Nation allowed me access to its photographic archives, and I am grateful to Rosie Cayou James and Jason Ticknor for their assistance. I would like to thank the American Croatian Club of Anacortes and also thank everyone who shared stories and permitted me to use photographs from their private collections: John Tursi, Phyllis Ennes, Vince and Mary Dragovich, Anita Penter Murphy, Ardith Kelley, Roy Maricich, Phil McCracken, Dave Milholland, the Demopoulos family, Arnold Moe, Kay Andrich, Fran Svornich, Catherine Foss, Sylvia Barcott, Irv and LaVerne Rydberg, Claudia Lowman, Linda Holmes, Branko Jurkovich, Ivan Suryan, and historian/muralist Bill Mitchell. Unattributed photographs are part of the author's collection. This book was made possible by the loving support of my family, the capable guidance of Sarah Higginbotham at Arcadia Publishing, and the generous loan of equipment from Phil Elverum and Geneviéve Castrée.

This is not the first book covering the history of Anacortes. It should be seen as a photographic overview of the first half of the 20th century. Please refer to the bibliography on page 127 for a partial list of the books that inspired and informed this volume.

INTRODUCTION

Located on the north shore of Fidalgo Island in Washington State's Puget Sound, Anacortes was founded in 1879 by railroad surveyor Amos Bowman and named in honor of his wife, Anne Curtis. Bowman promoted Anacortes as the "New York of the West," ultimately failing to establish the urban center he envisioned. But those who were drawn to Anacortes established a vital and unique small town that progressed to All-American City status by 1962.

Prior to 1890's boom and bust, Fidalgo Island was home to the Samish and the Swinomish people for thousands of years. Old-growth cedar and Douglas fir trees dominated the landscape from seashore to lakeshore. Members of the Samish tribe lived in cedar longhouses measuring over 1,000 feet; their Guemes Island longhouse stood into the 20th century. These Coast Salish tribes oriented their villages toward the abundance of the sea and built a wealthy and sophisticated culture based on harvesting salmon and shellfish and fashioning clothing and basketry from natural materials, while plying the waters in canoes for trade, harvest, and occasional raids.

Spanish and British explorers arrived in the late 1700s to map and name many of the surrounding islands and waterways: Rosario Strait, Guemes Channel, Padilla Bay, and the San Juan Islands. White pioneers began arriving on Fidalgo Island in the 1850s and were drawn to the meadowlands of March Point for their settlements—now the site of two oil refineries—because the land was already clear for farming. The settlement of Anacortes required the removal of mammoth trees, and the abundance of wood supplied early lumber mills, providing the materials for Anacortes's homes, stores, wharves, even the planking for streets.

Early settlers initially lived as neighbors to the Samish and Swinomish people. Yet as echoed throughout the American continent, this early cooperation did not endure. The 1929 edition of the high school yearbook states the matter plainly, "About 1860 the first settlers began dispossessing the Indians of Ship Harbor, as Anacortes was first called." Once these Native Americans' land was taken, following the Point Elliott Treaty of 1855, many moved to the Swinomish Reservation on southeast Fidalgo Island or made homestead claims on their own homelands on Guemes or other islands. Thus the land around Anacortes was opened to homesteaders and downtown investment schemes.

Real estate speculation, linked to railroad rumors, sparked the rapid growth of the budding city in the early 1890s. Although the first train arrived later that year, it never became the promised major terminus, so Anacortes's urban ambitions went into hibernation. Investors big and small suffered major losses when the real estate bubble burst in late 1891, triggered by a lack of money at the Oregon Improvement Company, which was unable to complete tracks over the Cascade Range. Owners defaulted on Anacortes property, and pages of the *Anacortes American* were full of Fidalgo Island property tax citation notices.

Those who fled the Anacortes "bust," which foreshadowed the nationwide Panic of 1893, were replaced on Fidalgo Island by fishermen, more farmers, cannery workers, lumberjacks, shingle weavers, shipwrights, carpenters, ferrymen, barkeepers, ministers, hoteliers, and others with a

more grounded vision of the town's future. Anacortes was promoted as the "City of Smokestacks" in the 1920s, with timber mills lining its eastern shore, salmon canneries lining its northern shore, and taverns lining its main street—P Avenue—which was changed to the less vulgar Commercial Avenue.

The fishing tradition depicted in television's *The Deadliest Catch* began in the 1890s as Anacortes men ventured to Alaskan waters for months of danger at sea. The town's early fishing industry was based on schooners like *Lizzie Colby* and *Wawona* that sailed from Anacortes to the Bering Sea and brought back tons of salted cod, which was then dried on racks, packaged, and shipped internationally. Mechanized salmon processing began in 1894 at the Fidalgo Island Canning Company and expanded to 11 seafood canneries operating along the swift-moving Guemes Channel, allowing Anacortes to boast of being "the Salmon Canning Capital of the World." The salmon fishery attracted immigrants: fishermen from Scandinavia and Croatia, cannery workers from Japan, and Chinese men, who sometimes arrived illegally on the boat of Laurence "Smuggler" Kelly.

Smugglers, bootleggers, sailors, fishermen, lumberjacks, and other adventurers created an atmosphere of a frontier town, which would remain a part of Anacortes for decades to come. This was balanced by teachers, ministers, boosters, and laborers who, thanks to hard work in a land rich in resources, survived periodic hard times and a rowdy past to succeed in becoming a proper city.

The early Anacortes waterfront buzzed with the "mosquito fleet," a flurry of big and small steamships and little gas launches that connected Puget Sound's communities during an era when roads were inferior to water travel. International and interisland travelers depended on these passenger boats and later the car ferries of the Black Ball Line, which evolved to become the current state ferry system. As a maritime hub, Anacortes was able to bring in boatloads of revelers; having a more relaxed attitude about temperance attracted celebrants from the drier parts of Skagit County. This tradition of celebration extended to the Marineer's Pageant, a summertime water festival that included floats on parade, water-skiers pulled by airplane, canoe and hydroplane races, and tours of visiting naval vessels. This pageant established Anacortes as a tourist destination, attracting throngs from the 1930s to 1950s, and is regarded as the precursor of Seattle's Seafair.

Of the more than 700 sons and daughters of Anacortes who served their country in World War II, many came back home. Wallie Funk, whose grandparents arrived in the 1890s, purchased the local *Anacortes American* newspaper in 1950. Sensing economic stagnation, Funk became a catalyst for both change and preservation of history. Inspired by Dr. Richard Poston's book, *Democracy Is You*, Funk and others pursued a "do it yourself" community development program involving more than 1,200 of Anacortes citizens.

Meanwhile, on March Point's meadows, land was being quietly acquired by Shell Oil as a site for a refinery that promised to fill gaps in the economy left by closure of several mills. The arrival of Shell in 1953 and Texaco in 1957 created jobs for locals and brought in a wave of newcomers to the community. Old and new ideas and problems challenged the community's past identities, requiring arguments, compromise, and sacrifice. New schools replaced old, gravel streets were paved, flood-prone creeks were routed into underground pipes, and whole neighborhoods were condemned.

This volume concludes at the dawn of the 1960s, when Anacortes became an All-American City, while the lumber and fishing industries held on to some vitality before diminishing rapidly in the following decades. Anacortes weathered the rapid changes of the 20th century with many of its traditions intact: good schools, preservation of nature balanced with working-class jobs, encouragement of artists and adventurers, and open arms for celebrants and visitors.

One

Magic City

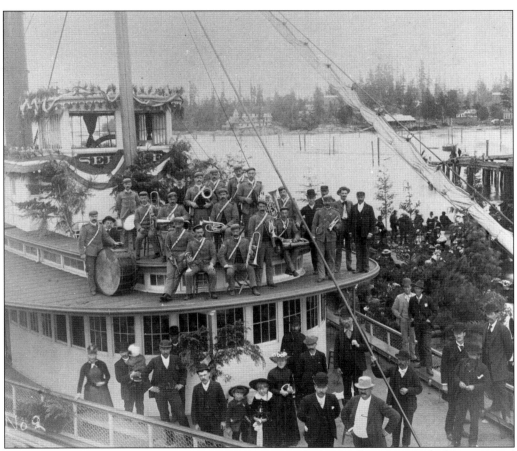

The 192-foot *Sehome* visits on July 4, 1890, at Ocean Dock, the northernmost end of Commercial Avenue. The Anacortes Community Band is aboard with their instruments. Looking east toward Cap Sante is the Bowman Hotel, which burned completely on December 26, 1891. (Photograph by J. O. Boen, courtesy Anacortes Museum.)

A canoe (below) approaches the Guemes Channel shore of early Anacortes. Among the few white newcomers who courted Native American wives were the Wooten brothers, Richard and Shadrach, who ventured north from California after the Gold Rush of 1849. They married the Samish sisters Ellen (left) and Mary Toney, respectively. White attitudes like those expressed in 1890s Anacortes referred to Native Americans as "dusky people" and to the Wootens as "squaw men." As more settlers arrived on Fidalgo, the Wooten families moved to Cypress and Guemes Islands. Ellen married Humphrey Posey O'Bryant after Richard Wooten's death in 1882; she lived to be 104 years old. (Both courtesy of the Anacortes Museum.)

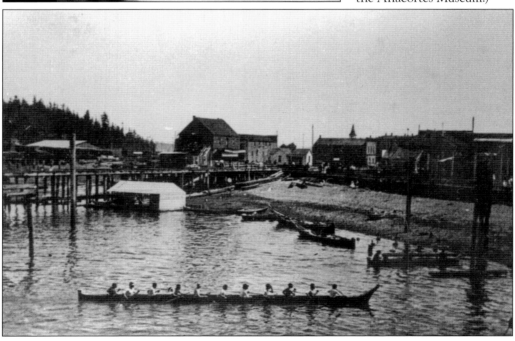

Anne Curtis Bowman, the town's namesake, settled on the north shore of Fidalgo Island in 1876 with her husband, Amos Bowman. Together they promoted the town, hoping to profit from the possibility it would be selected as a terminus for one or more railroads. While the town grew, it never realized the Bowmans' dream of a metropolis. Anne Bowman left her town after Amos's death in 1894. (Courtesy of the Anacortes Museum.)

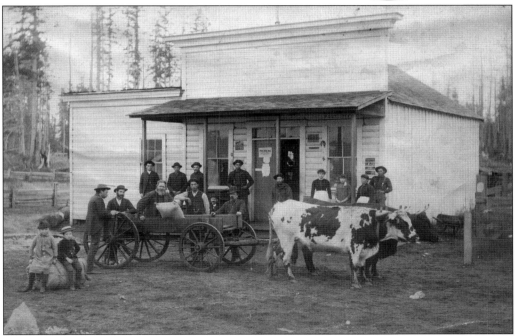

A wagon stops at Amos Bowman's store in this early street scene, near Guemes Channel in the vicinity of Third Street and Q Avenue. Bowman's other ventures included a lumber mill and hotel near Cap Sante. He also established a post office and began promoting it as Anacortes in the pages of his *Northwest Enterprise*; until that time, the tiny settlement was known as Ship Harbor. (Courtesy of the Anacortes Museum.)

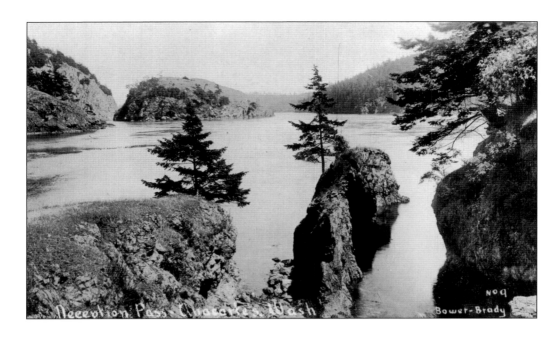

Deception Pass was named by Capt. George Vancouver because he at first thought the strait was a bay. Flooding and ebbing currents reach a maximum speed of 9 knots. The photograph above gives a pre-bridge view of this beautiful location. These waters provide a route to Anacortes via Skagit Bay and the Swinomish Channel. Rosario Head, seen below, is part of Deception Pass State Park on the southwestern end of Fidalgo Island. Steep cliffs overlook the Strait of Juan de Fuca as it funnels into Deception Pass. These beaches were home to the Samish tribe, who erected the Maiden of Deception Pass, a carving by Tracy Powell that depicts traditional tribal beliefs. (Both photographs by Ferd Brady, courtesy of the Anacortes Museum.)

Komo Kulshan is the Lummi tribe's name for Mount Baker (elevation 10,778 feet), a volcano in the Cascade Range seen here looking northeast from Cap Sante. In the foreground of this view are the aptly named islands, Dot and Hat. Cap Sante was known as Bowman Hill until 1903. It was donated to the City of Anacortes for a park by Melville Curtis, the brother of Anacortes's namesake. (Photograph by C. L. Judd.)

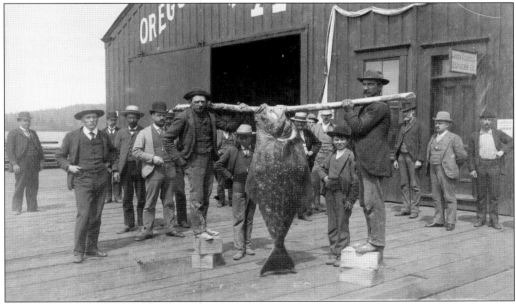

This 1890 shot of a "barn door"–sized halibut was taken at Ocean Dock, built by the Oregon Improvement Company at the foot of what it is now called Commercial Avenue. The original caption reads, "Halibut caught off Ocean Dock, Anacortes, July 9, 1890." The men are standing on candle boxes. The sign above the door reads, "North Western Express Co." (Courtesy of the Anacortes Museum.)

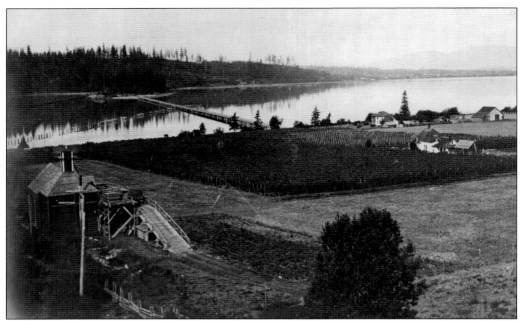

In the 1850s, Hiram March, Enoch Compton, and William Munks were among the first white settlers to begin farming on March Point, an especially attractive meadow when compared to the thick forest covering the rest of Fidalgo Island. Here a wagon bridge crosses Fidalgo Bay to Weaverling Spit, with the train trestle visible to the far left. Note the hop fields under cultivation and the ramp to a hop processor. (Courtesy of the Anacortes Museum.)

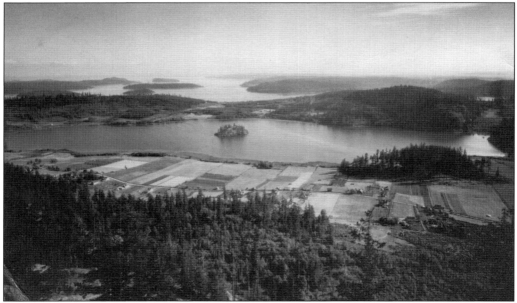

This inspiring view from Fidalgo's highest point, 1,273-foot Mount Erie, faces southeast toward Skagit Bay, Whidbey Island, and the Cascade Range. Campbell Lake, noteworthy for its "island on an island," was surrounded by agricultural activity, which supported a community of mostly Scandinavian farming families.

A portrait by Anacortes photographer Lance Burdon shows a man posing before an immense old-growth cedar tree. Rare pockets of these giants still stand in the Anacortes Community Forest Lands, a 2,800-acre preserve established by the city. Most of Fidalgo Island was logged by the 1920s, but an abundance of timber from other islands and the nearby foothills of the Cascade Mountains kept Anacortes mills buzzing for several decades.

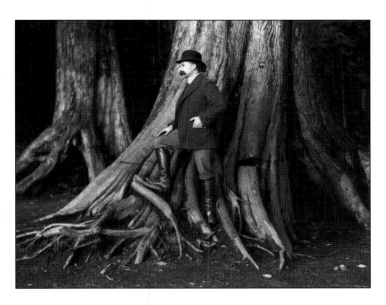

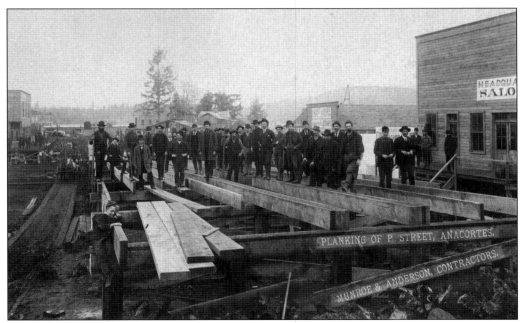

The abundance of timber, once milled, was a resourceful solution to the battle against Washington's rains. Massive planks extended from the Oregon Improvement Company's Ocean Dock southward through the budding metropolis toward the forest still covering most of Fidalgo Island. Horses, carts, bicycles, and strollers made use of the passable main street. (Courtesy of the Anacortes Museum.)

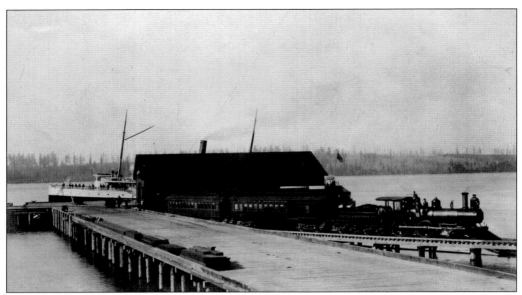

The arrival of Anacortes's first train was cause for celebration in 1890 and sparked the long awaited boom in Anacortes real estate. While the Bowmans worked to establish the commercial district on P Avenue, other developers, led by Seattle lawyer James McNaught, had invested in land 10 blocks west. Here the Seattle and Northern train arrives as the gangway is lowered for an unidentified steamboat docked on Guemes Channel. (Courtesy of the Anacortes Museum.)

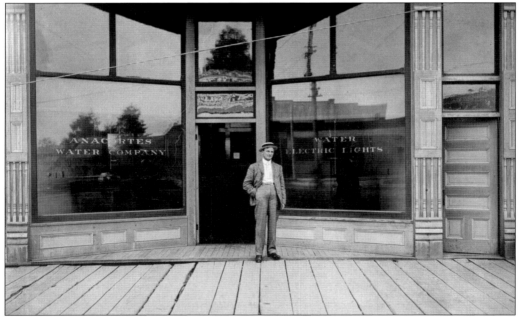

Douglass Allmond founded the *Anacortes American* with F. H. Boynton in 1890, with the intention stated in their first edition, "To publish an honest, independent, aggressive newspaper that shall tell the story of our marvelous city and its surroundings." In 1902, he became president of the water and electric light companies. His donation of forested acreage around the city, with the condition that it be preserved, has been his most lasting gift. (Courtesy of the Anacortes Museum.)

Two

LOCAL LANDMARKS

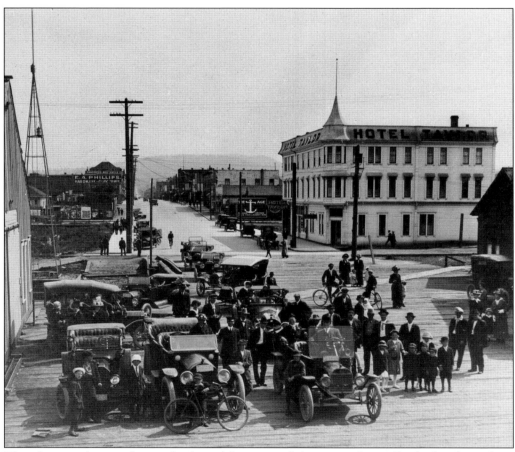

This photograph was taken at the foot of Commercial Avenue at Ocean Dock, the place where most travelers arrived and departed until autos and roads became more convenient than water travel. Behind the fleet of bikes and cars is the Hotel Taylor, seen in the background of this book's cover. Southward on Commercial is the Anchorage, which became the location for "Mike" Demopoulos's Marine Supply. (Courtesy of the Anacortes Museum.)

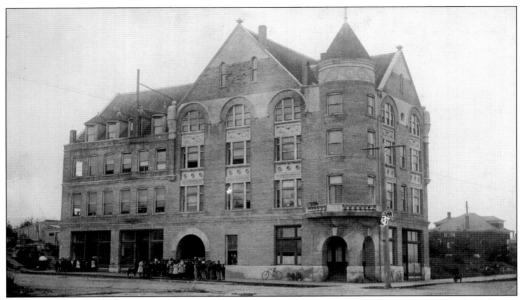

The Anacortes Hotel had a very limited run. Built by George Kyle at the corner of Eighth Street and J Avenue, it banked on being located in the heart of the business district. The hotel opened in 1891 and folded by the Panic of 1893. Commercial Avenue won out as the business center, but Kyle's building stood until 1989, housing Whitney School in this photograph and other endeavors. (Courtesy of the Anacortes Museum.)

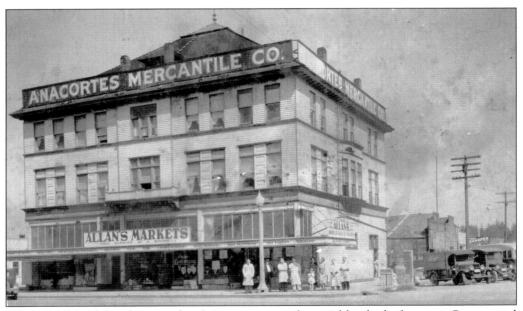

While Kyle's brick hotel was stuck at J Avenue, its wooden neighbor had a future on Commercial Avenue. The McNaught Building was constructed originally at Eighth Street and I Avenue. In 1904, it was moved 11 blocks to its current location at Fifth Street on Commercial. In this photograph, it is home to the Anacortes Mercantile and Allan's Market, offering "Table Supplies at a Savings" as delivery trucks stand ready. (Courtesy of the Anacortes Mural Project.)

Anacortes's first brick building was constructed in 1890 for John Platt's bank. W. V. Wells acquired the structure following his return from the Klondike in 1900; he replaced the wooden sidewalk in 1904. Pictured from left to right are unidentified, Ruby Raddatz, Maude Trafton, E. A. Phillips, unidentified, Harry Deane, and unidentified. By 1912, Phillips Hardware moved across Commercial Avenue. Maude married Bill McCracken, whose father's bar is visible on Fourth Street. (Courtesy of the Anacortes Museum.)

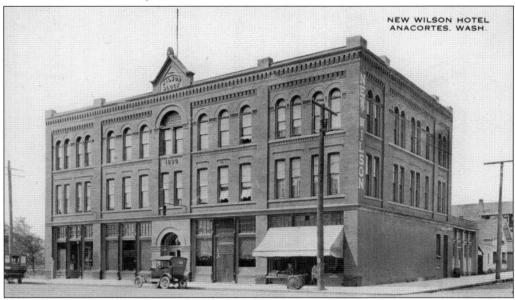

Tacoma railroad investor David Wilson spent $35,000 building the Wilson Hotel at Eighth Street on Commercial Avenue in 1890, constructed with a million bricks from See's Brickyard in Anacortes. He lost it to creditors before the beginning of the 20th century, and they in turn sold it to the enterprising Funk family. (Courtesy of the Anacortes Museum.)

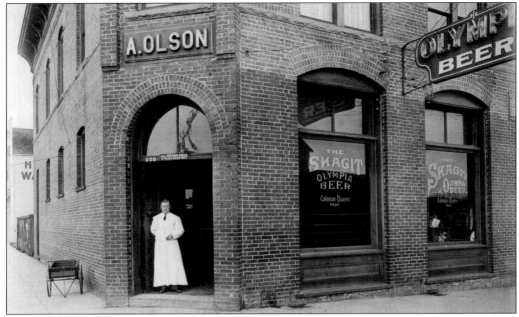

Alfred Olson built a two-story brick structure, around 1900, at Third Street and P Avenue. The Skagit Saloon (above) operated at the south corner. The bartender in the doorway is unidentified but is perhaps the Coleman Queen listed as proprietor on the window. Queen was mayor in 1921–1922. The State Bar (below) conducted business at the north end of the Olson Building, run by F. A. "Grab" Whimsett; hence "Grabs Place" is painted on the windows of the front doors. This was also the location of Skipper's tavern at mid-century, by which time the building was owned by E. "Mike" Demopoulos of the neighboring Marine Supply and Hardware. Statewide Prohibition in 1916 created a challenge, which caused these beer joints to offer pool and soda as alternatives. (Both courtesy of the Anacortes Museum.)

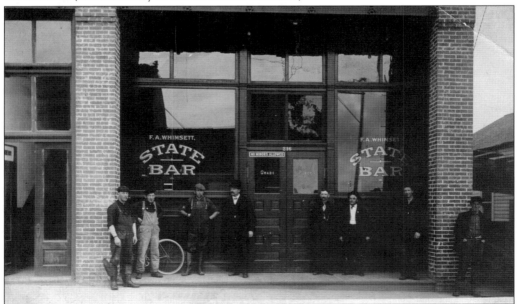

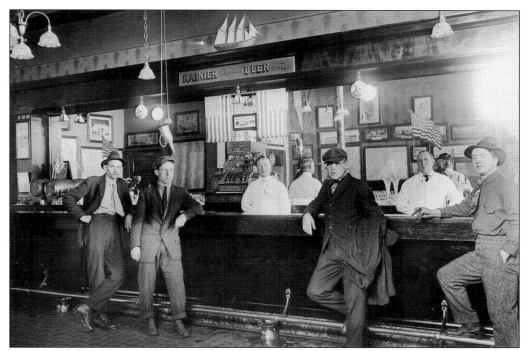

In the Union Bar (above), the National cash register has just rung up a 40¢ sale, and above it, a sign bids these unidentified customers "Thanks—Please Call Again. Geo. W. Wilkes." Moonlighting at the Heidelberg (below), the same bartender serves another set of unidentified rough customers. On the wall is a poster advertising a Labor Day dance. Unions were very powerful in Anacortes throughout the early 20th century. (Above, courtesy of the Anacortes Museum; below, the McCracken family.)

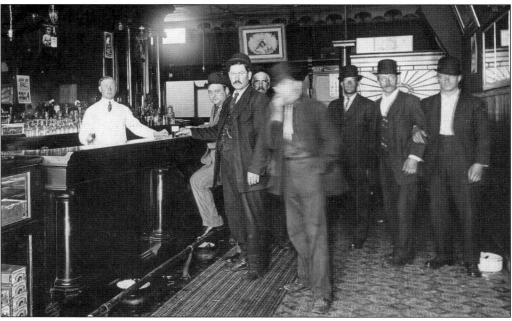

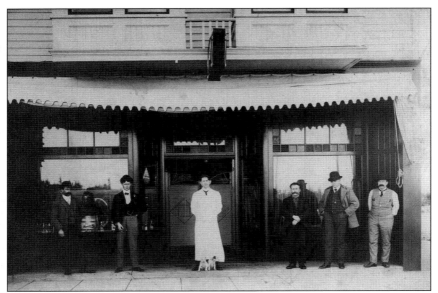

Frontier Anacortes was dominated by drinking establishments, thus creating a niche for the No Bar Hotel, a sober refuge for travelers. Had it still been operating, it would surely have provided accommodations for "bar breaker" Carrie Nation, who visited Anacortes's Women's Christian Temperance Union in 1910. The Rainier Bar, seen above, was one of Frank McCracken's (far right) taverns. When Washington State prohibited booze in 1916, not only did bars close, but also the Anacortes Glass Factory, which depended on beer bottle production. Chalking a billiard cue below is John Wagner, proprietor of Wagner's pool hall, erected in the 300 block of Commercial Avenue in 1905 and named the Louvera. Situated between the Joker Bar and the Iowa Bar, Wagner's operated through Prohibition, offering tobacco products and magazines. (Above, courtesy of Phillip McCracken; below, the Anacortes Museum.)

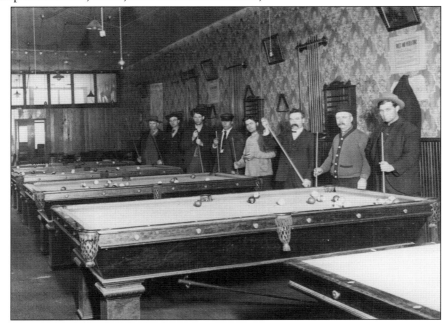

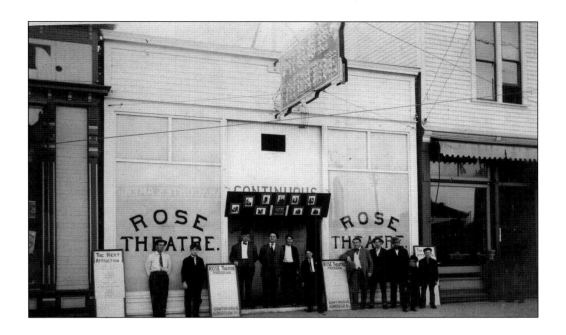

In the first decade of the 20th century, the Rose Theatre offered continuous entertainment, including vaudeville and a "Spirit Act" advertised on the sidewalk signs. In the photograph above, the Rose was located on the west side of Commercial Avenue between Seventh and Sixth Streets, next to the still standing Shannon Building. This snowstorm of 1916, seen below, finds the Rose Theatre at a new location, next to the Vendome Hotel between Fifth and Sixth Streets on Commercial's east side. Posters on the wall advertise silent films *Don't Marry* and *The Escape*. The Rose Theatre burned in 1928, causing a loss of $6,000. (Above, courtesy of the Anacortes Mural Project; below, the Anacortes Museum.)

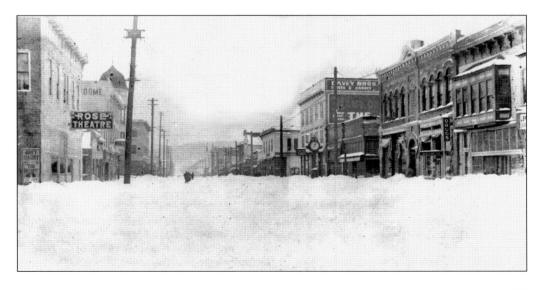

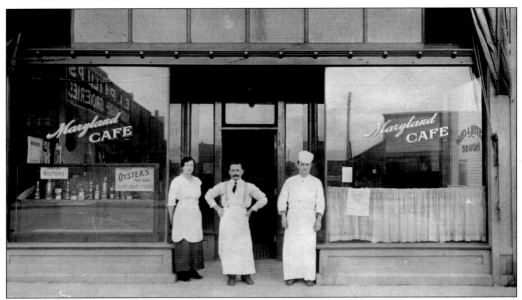

The Greek American George and Della Marinakos family operated the Maryland Café, an "Oyster and Chop House" on the west side of Commercial Avenue between Third and Fourth Streets. Advertisements from 1925 state, "We never close. Short orders served at all hours." Posters in the window offer fresh oysters by the pint, quart, or gallon, and another promotes a local basketball game. The Marinakos family resided at 1119 Fifth Street and raised daughters noted for academic success at Anacortes High School. Pictured on the sidewalk (above) from left to right are Mildred O'Brien, unidentified, and George Marinakos; and behind the counter (below) from left to right are Athena Marinakos, Alfie Moen, Mildred O'Brien, and unidentified. (Both courtesy of the Anacortes Museum.)

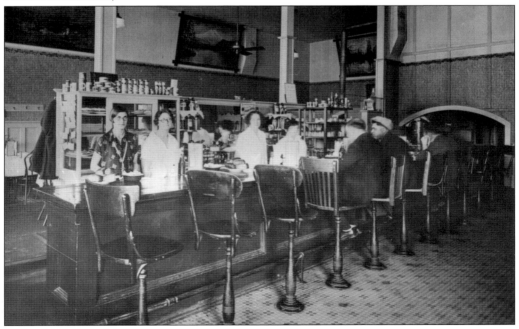

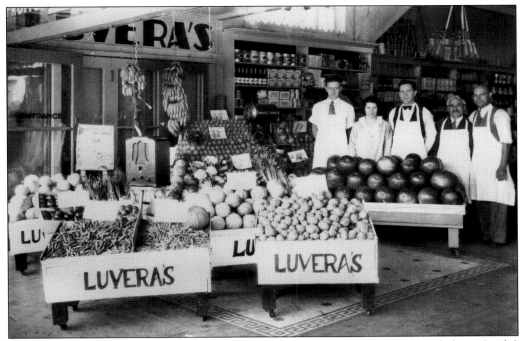

Luvera's Market was operated by Paul Luvera (far right with arm around his father, Nicolo) beginning in 1922 at the southwest corner of Seventh Street and Commercial Avenue. At a time when several small grocers competed for the table needs of Anacortes, Paul Luvera made free home deliveries twice daily and always greeted customers by name. (Photograph by Ferd Brady, courtesy of the Anacortes Museum.)

Greek immigrant Mike Demopoulos (right) prospered through resourcefulness and hard work with his Anacortes Junk Company and soon expanded operations to the former Anchorage location, opening Marine Supply and Hardware. This photograph shows wooden sidewalks and the junk company down Second Street at the far right. (Courtesy of the Demopoulos family.)

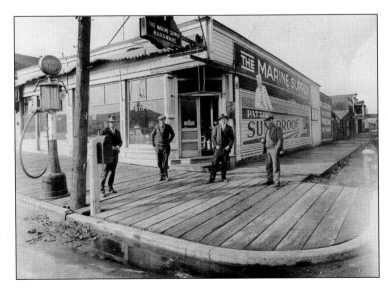

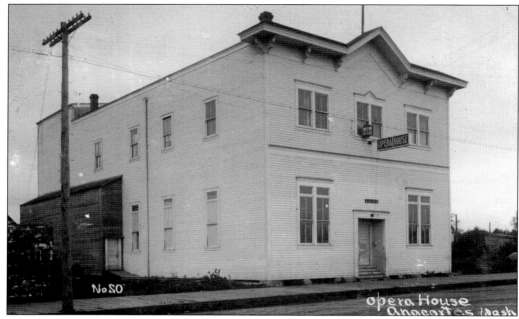

The Independent Order of Odd Fellows formed an Anacortes lodge in 1891. Their 1900 building also contained an opera house, which featured a variety of events including traveling musicians, lecturers, and dramatists. Located in the 1100 block of Sixth Street, it served as storage after the IOOF moved to a new location. It burned in 1981. (Courtesy of the Anacortes Museum.)

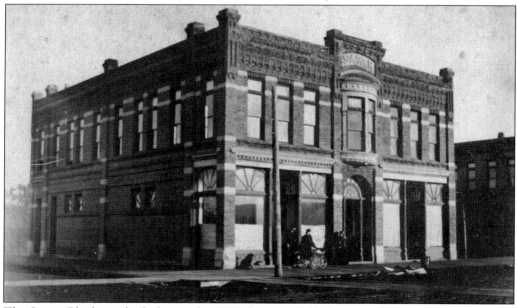

The Semar Block was built during the 1890s boom at Fifth Street and Q Avenue. In 1905, the town's first hospital was established here by doctors Edward Butler and Winston Appleby. The *Anacortes American* described it as a "palace of neatness" for which a $10 ticket would cover all hospital and surgery needs for a year. It later housed the West Coast Creamery below and a house of ill repute above.

To be an Empire Theater usherette was as much a mark of social status as it was a paying job. It might also lead to royalty of the Marineer's Pageant, based on one's ability to sell event tickets. Usherettes posing here at 620 Commercial Avenue are, from left to right, Wilma Murdock, Beth Martin, Leeta Bowen, Lois Means, and Marie Bozanich, who achieved royalty in the 1940 pageant. (Photograph by Ferd Brady, courtesy of the Anacortes Museum.)

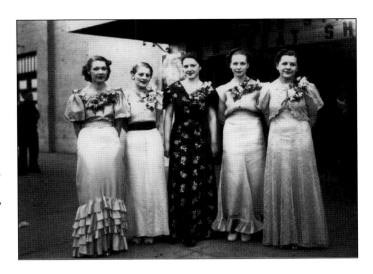

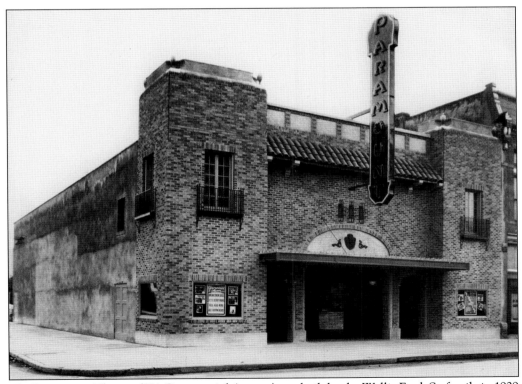

The Paramount Theater (801 Commercial Avenue) was built by the Wallie Funk Sr. family in 1929 and equipped to show the first talking pictures in Anacortes. When the Great Depression hit, the Funks were among several entrepreneurs who lost both home and business. Posters on display advertise director Frank Capra's 1928 hit *Submarine*. (Courtesy of the Anacortes Museum.)

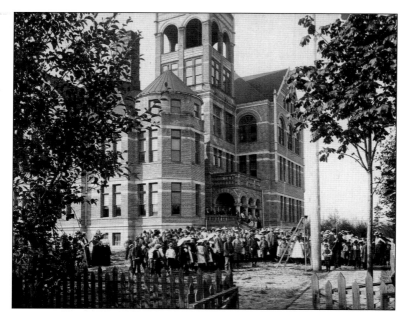

Built at Seventeenth Street and J Avenue, the Columbian School opened in 1892 and was demolished in 1966. The schoolchildren in this 1901 photograph were the ones whose parents decided to stick it out in Anacortes, despite the collapse of its "New York of the West" pretensions. The scale and style of the Columbian School reflected the grand old vision of the city's future.

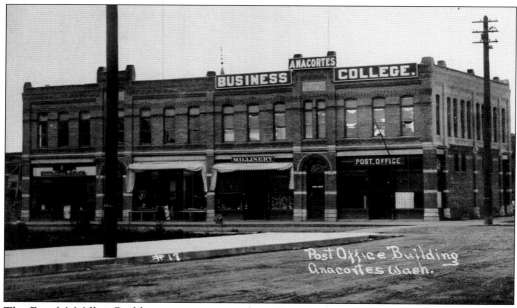

The Frye-McMillan Building was constructed on the corner of Sixth Street and Q Avenue in 1891. Wilson Shank's Anacortes Business College moved from the old Anacortes Hotel to this downtown location in 1905. Other tenants at the time of this photograph were the *Anacortes Citizen*, operated by Professor Shank and his wife, Nannie. The post office occupied this location from 1903 to 1915.

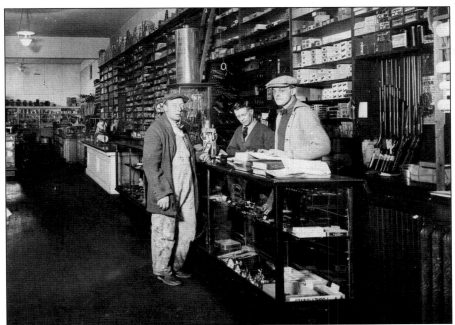

Anacortes Hardware was one of several such businesses lining Commercial Avenue, competing with Shannon Hardware (established 1890) and E. A. Phillips Hardware. The above interior photograph, taken in 1925, shows Ralph Handy (center) helping an unidentified pipe-smoking customer while his colleague looks on. A 1925 yearbook advertisement reads, "We sell hardware plus service," and offers Spaulding Brothers athletic goods and Great Western banquet ranges. Seen below, from left to right, are Maude Trafton, Harry Deane, and Eugene A. Phillips, likely in Phillips's new building (1911) at the northeast corner of Fourth Street and Commercial Avenue. (Above, courtesy of Kay Andrich; below, the Anacortes Museum.)

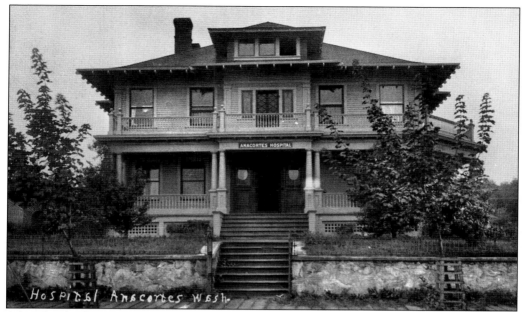

After the death of Capt. Charles Matthews, doctors purchased his palatial home at 1317 Fifth Street. The Anacortes Hospital, organized in 1905, reopened here in 1911 but moved a few years later. Ray and Jean Lowman purchased the home and lived in it until a fire razed the hospital in 1928. The Lowmans moved their large family into apartments and loaned their home for hospital use while a new hospital was built.

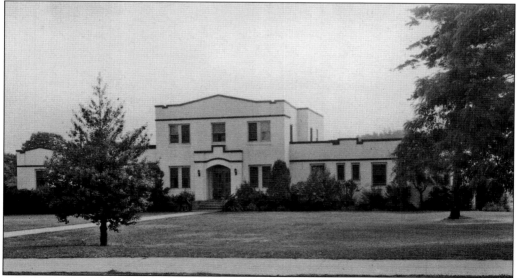

After repurposing several houses for decades, the community began fund-raising in 1928 to build a modern hospital after fire leveled the old hospital at Thirty-second Street and M Avenue. Constructed at a cost near $35,000 and located between M and N Avenues on Ninth Street, the new hospital opened in 1930. It served the community's and area's needs until being replaced by Island Hospital in 1962. The library moved here in 1967.

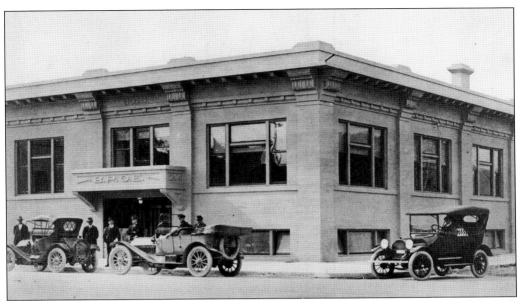

After an 1893 fire destroyed E. W. Moyer's wooden structure at the northeast corner of Seventh Street and Commercial Avenue, he revised his rebuild upward when the local Elks Club convinced him to add a third floor for their ballroom. The Moyer building served the Elks until they built their own structure in 1915 (above) at the northwest corner of Sixth Street and Q Avenue. In 1922, they completed a major expansion (below) to hold increased membership and host the State Elks Convention in that year. By 1937, the Elks moved to 1009 Seventh Street. From that point, the old Elks Lodge became known as the Community Building and was the site of dances and other events. It also housed the Red Cross and served as a barracks for troops during World War II. In 1947, it became the Anacortes City Hall. (Both courtesy of the Anacortes Museum.)

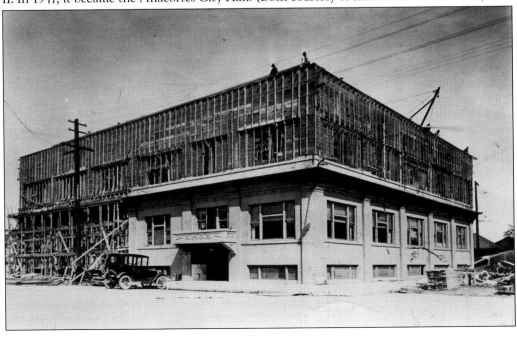

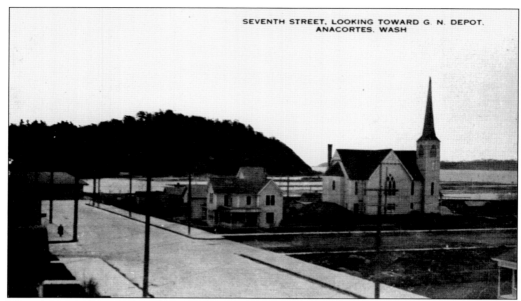

This photograph was taken from the top of the Moyer Building toward Cap Sante after the 1911 completion of the Great Northern Depot on R Avenue but before the 1920 construction of the Eagles Aerie 249 on the corner of Seventh Street and Q Avenue, until then a site of summer Chautauquas. The steeple of the First Methodist Episcopal Church at Eighth Street and R Avenue points heavenward.

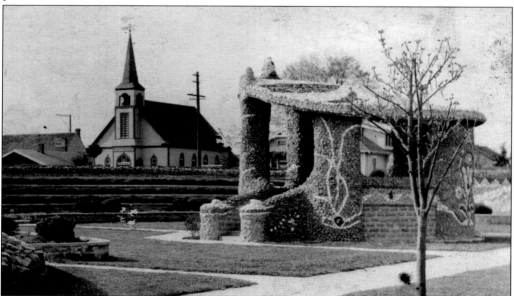

On a block donated by Great Northern Railroad, Causland Park was constructed as a memorial for soldiers killed in World War I and named after Harry Causland, recipient of the Distinguished Service Cross. A community effort spanning 1919 to 1921 followed the designs of French-Canadian artist John Baptiste LePage as he led volunteers in hunting and placing rocks into mosaic structures. Behind stands the old St. Mary Church, built in 1904 and burned in 1924. (Courtesy of the Anacortes Museum.)

Three

ALONG THE WATERFRONT

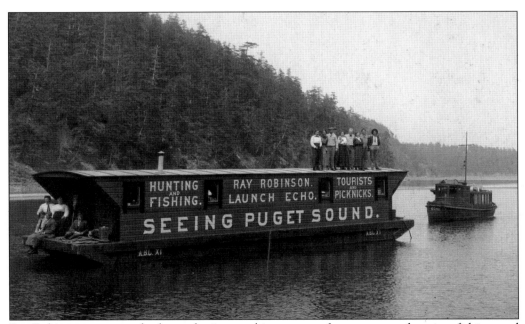

Ray Robinson ran an early charter business, taking groups of passengers on hunting, fishing, and "picknicking" excursions on this houseboat barge, boldly painted to leave no doubt of "seeing Puget Sound." The launch *Echo* floats nearby, ready to tow these happy campers to their next destination. (Courtesy of the Anacortes Museum.)

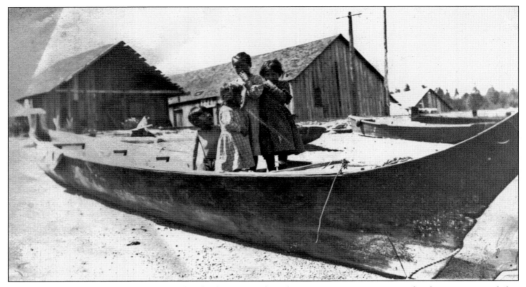

Canoes remained the primary vehicle for many local Native Americans at the beginning of the 20th century and were used to reach jobs in canneries or hop fields or to travel for trading and social gatherings. On the back of this photograph is written, "Indians as children, Anacortes 1911." (Courtesy of the Anacortes Museum.)

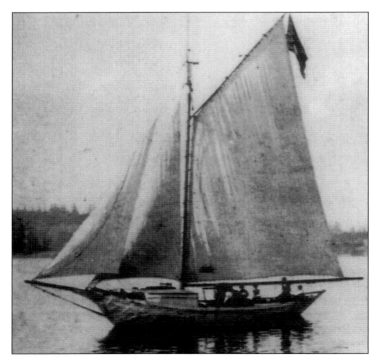

The *Katy Thomas* was the ketch-rigged sloop that Laurence "Smuggler" Kelly sailed fearlessly while trafficking in opium, furs, and illegal Chinese workers entering the United States from Canada. Legend describes Kelly as a ruthless ex-Confederate soldier who turned to crime after Lee's surrender. His piracy throughout the San Juan Islands was based from a point on Guemes Island that still bears his name. He left here following imprisonment in 1909. (Courtesy of the Anacortes Museum.)

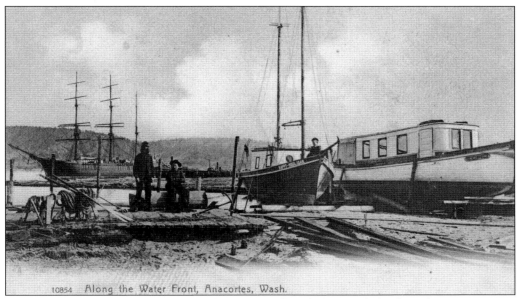

10854 Along the Water Front, Anacortes, Wash.

This 1916 postcard captures something between work and play entitled "Along the Water Front." Kids are aboard the *Happy Hooligan*, with *Echo* beside, also on ways. Clouds fill the sky over Guemes's hills. The waterfront had a rough side, too. The skipper of cod schooner *Alice* was murdered for his pay in 1919 and tossed overboard in one of the many early crimes along the waterfront. (Courtesy of the Anacortes Museum.)

Pride of ownership is evident in this turn-of-the-20th-century portrait of the fantail launch *Cupid* and its owner, Frank Judy. This steam-powered vessel was typical of the passenger ferry and mail boats that were ubiquitous on the Puget Sound and so referred to as the Mosquito Fleet. *Cupid* was likely powered by the abundant cordwood of the Northwest. A 1902 storm washed her onto Fidalgo's northern shore. (Photograph by Lance Burdon.)

This *c.* 1900 Lance Burdon photograph shows shipwrights along Anacortes's north shore at work on a large skiff. There was nothing fancy about this open boat hull under construction. This is possibly the operation of Burdon's cousin Harry Rickaby, who built boats at the foot of Q Avenue beginning in 1893. Later Rickaby established a marina— or float—here and a Guemes ferry run in 1912 using the *Elk*.

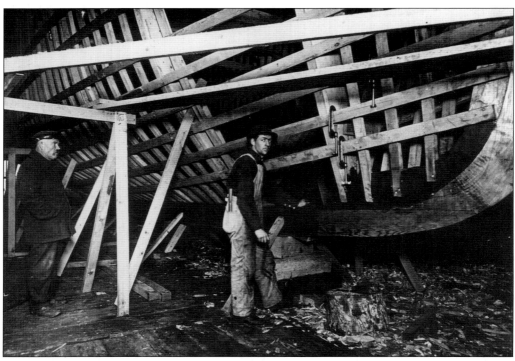

"Known among men as Honest John" reads the tombstone of John Babarovich (left), the first Croatian immigrant to Anacortes. Arriving to homestead on Sinclair Island in 1879, he moved his family to Anacortes and pioneered the purse seine fishery. In 1912, John Taylor (right) built the *Uncle John* for Babarovich, the first gas-powered seiner in town and the first to sleep its crew aboard. (Courtesy of Phyllis Ennes.)

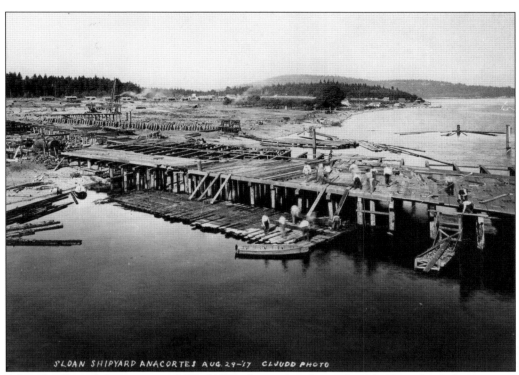

SLOAN SHIPYARD ANACORTES AUG. 29-'17 CLJUDD PHOTO

After the United States entered World War I, naval architect Joseph Sloan landed a contract with the government to build a dozen wooden oceangoing Liberty ships. On 20 acres of land he acquired west of the ferry landing on Guemes Island, Anacortes Shipways built five ways and began construction of the first vessels on each. Five boilers burning cordwood powered two 225-horsepower steam engines, which created both electric and steam power, used by the 600 employees. Workers either ferried over from Anacortes or set up tents nearby. But the war ended just three months before the first vessel, the SS *Asotin*, was launched on February 6, 1919. The photograph below reads, "*Leoti* and men who built her." These were the only two boats launched from Guemes by Sloan, who took his own life in 1922 following this financial collapse. (Both courtesy of the Anacortes Museum.)

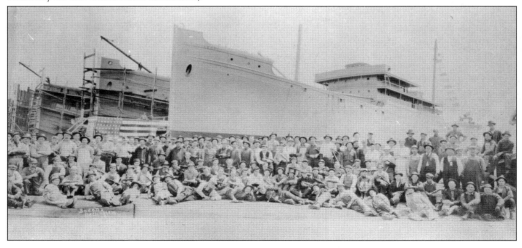

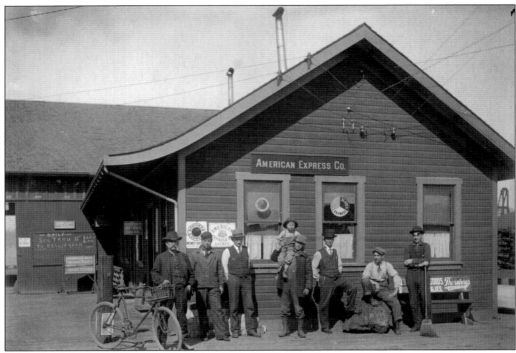

Melville Curtis, brother of Anacortes's namesake, operated this wharf at the foot of O Avenue until his death in 1925. In this 1906 photograph, a chalkboard lists 8:00 a.m. and 2:00 p.m. departures for the steamer *Taku* to Bellingham. The office and its employees also offered American Express money orders. In 1992, the buildings were demolished and the wharf rebuilt. (Courtesy of the Anacortes Museum.)

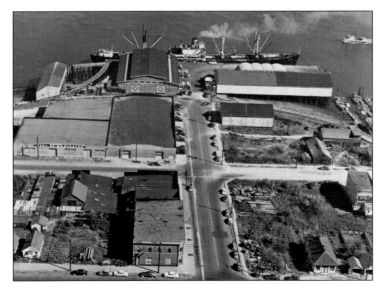

Taken from above the Olsen Building and Marine Supply block facing north, this photograph shows warehouses of the Port of Anacortes (formed in 1926). These warehouses replaced the Hotel Taylor on Second Street and Commercial Avenue. Buildings and vacant lots east of Commercial are now the site of Dakota Creek Industries, a shipbuilding company established in the 1970s to make King Crab boats.

The *Harvester King*, the first ferry on Capt. Harry Crosby's Anacortes-Sidney route, had been a kelp harvesting vessel previous to renovation for auto transport. Ferry service from Anacortes to Victoria, British Columbia, began in 1922. Passengers loaded at the dock at Q Avenue and rode to Sidney, outside of Victoria. The run attracted thousands of tourists from the start, and Puget Sound Navigation made plans for San Juan Island routes.

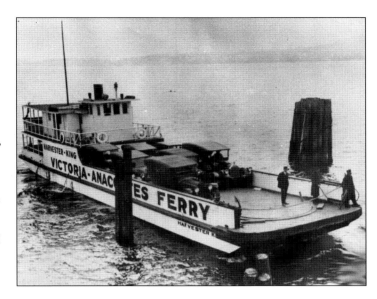

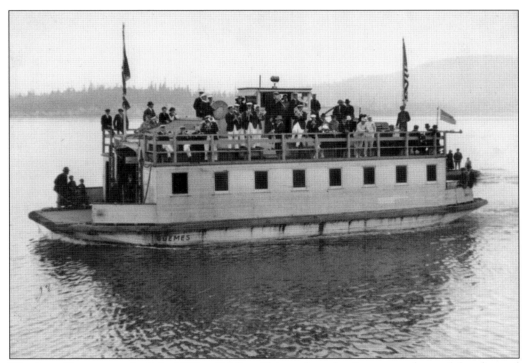

The ferry *Guemes* was built in 1917 at Keisling Shipyard on the Anacortes shore of the channel it was made to cross. Powered by a four-cylinder Atlas engine, it transported islanders and Sloan shipyard workers from Anacortes to Guemes. In 1920, Bill Bessner acquired the boat and in 1927 removed one passenger cabin to make room for up to six cars. Car and driver paid a 50¢ fare, and for passengers it was free for some time. (Courtesy of Bill Mitchell.)

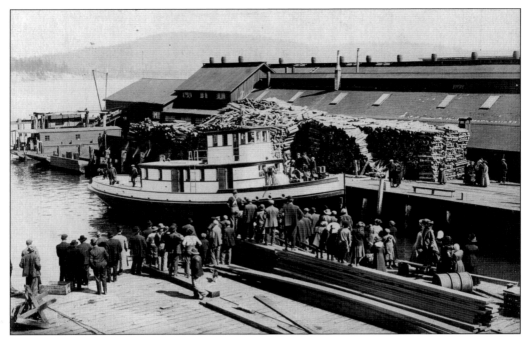

The *Beatrice Baer*, a ship built by Will A. Lowman in 1912 and named for his wife, is seen here at launch day at Lowman's Coast Fish Company. The *Beatrice Baer* was a crude oil–burning steam tug used in cannery and fish trap operations. Lowman sold the boat in 1917 to the American Fish Company. Today the ship's wooden nameplate hangs on the wall of the Anacortes Museum. (Courtesy of the Anacortes Museum.)

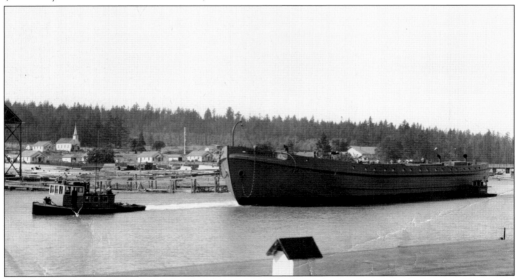

The tug *Gerry D* pulls a barge, U.S. Army BCL 327, through the Swinomish Channel between La Conner and the Swinomish Indian Reservation on the south end of Fidalgo Island. St. Paul's Church (built 1868) is visible. Anacortes Shipways produced many wooden barges for the army during World War II, the largest being the *Western Larch*; at 280 feet, it was the largest wooden vessel made in the United States since World War I.

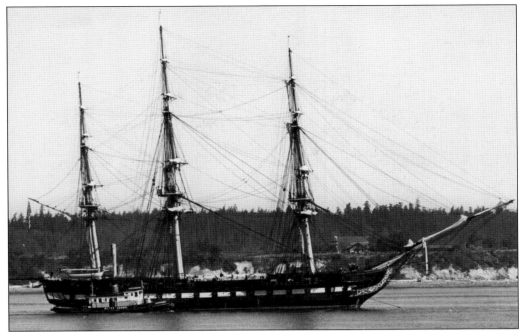

The USS *Constitution*, known as "Old Ironsides" since deflecting British cannonballs in the War of 1812, visited Anacortes in 1933 as part of a 22,000-mile, 90-port journey that welcomed over four million visitors. Here the then 140-year-old frigate is ushered through Guemes Channel by the Puget Sound tug *Chichamanga*. During a six-day Anacortes stay, 689 people visited and the town held parties for the crew. (Photograph by Ferd Brady, courtesy of the Anacortes Museum.)

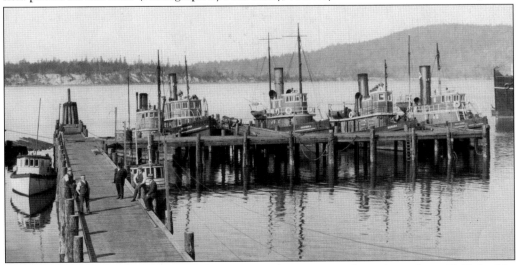

Tied up at the dock of the Gilkey Brothers Towing Company are the tugboats *Intrepid*, *Columbia*, *Bahada*, and *Sea King*. On November 21, 1927, while towing a raft of logs, the *Bahada* went down in Huckleberry Pass, taking with it the lives of a nine-member crew: Capt. George Hansen, James Hird, William Hansen, Charles Craig, John Knake, George Northrup, A. E. Bigham, L. Christensen, and Sam Brannion. The *Anacortes American* reported a "terrific boiler explosion" as the cause of the loss. (Courtesy of the Anacortes Museum.)

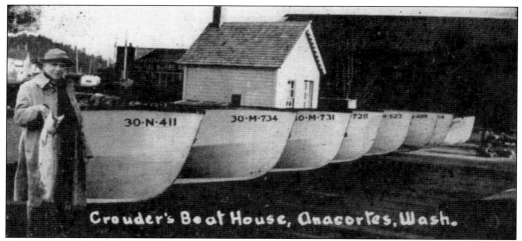

A person who missed the ferry had other options. Crouder's Boat House offered rental skiffs in the 1930 and 1940s, located at the north end of O Avenue. Both tourists and locals wanting to get somewhere, go fishing, or just spend a few hours on the water kept this early charter service afloat. For those who preferred dry land, W. J. Crouder also ran a pool hall.

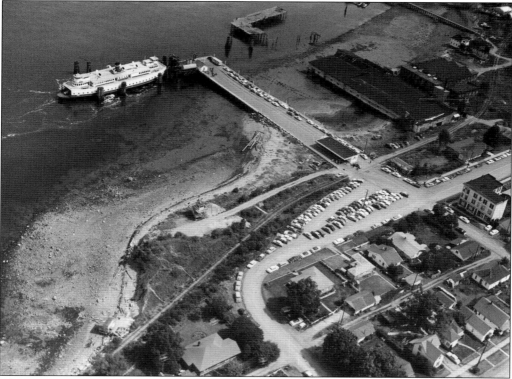

The Anacortes-Sidney ferry dock moved west from Curtis Wharf to the former McNaught dock at I Avenue in 1946. This aerial photograph was taken in 1960 on the last day at the I Avenue dock before service moved to the state ferry terminal at Ship Harbor. Aerial photography was a specialty of Glenn Davis, who teamed up with Wallie Funk to copy and print the first Anacortes Museum exhibit of pioneer photographs. (Courtesy of the Anacortes Museum.)

Bill Bessner (right) takes a self-portrait on the Lowman trap-tender *Caprice* in 1915. Trap and cannery tenders were tugs with fish holds and used to haul salmon as well as groceries, mail, and beer for fish trap crews. (Courtesy of Bill Mitchell.)

With pleasure this obvious, boating in the San Juans Islands is an attraction that has not been kept secret. The Anacortes waterfront has evolved decade by decade over the last century, shifting away from timber and seafood processing and toward pleasure boat moorage, maintenance, and manufacturing. Log booms and stacked lumber have been replaced by marinas and parking lots. (Courtesy of the McCracken family.)

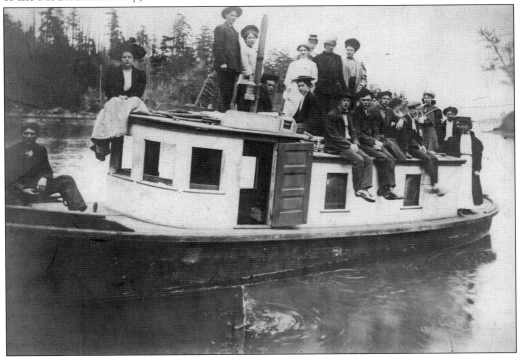

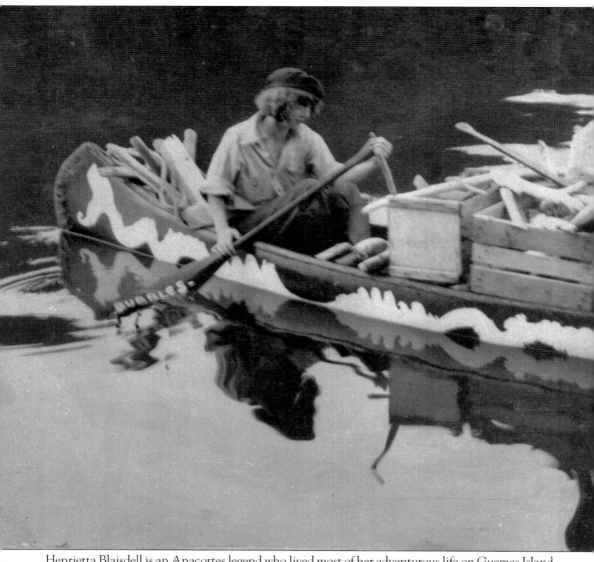

Henrietta Blaisdell is an Anacortes legend who lived most of her adventurous life on Guemes Island.
Known by the nickname "Bubble," she traveled from island to island in artistically painted boats
and canoes while hunting, fishing, and collecting firewood. A gifted storyteller, quilter, cartoonist,

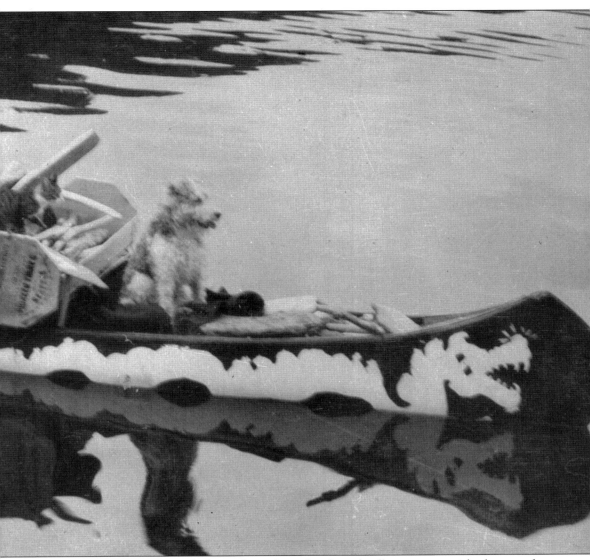

and party-thrower, as a youth she performed in a local vaudeville magic act with photographer Larry Kronquist. Here she paddles *Thanatus* with a load of firewood and her dog, Peter.

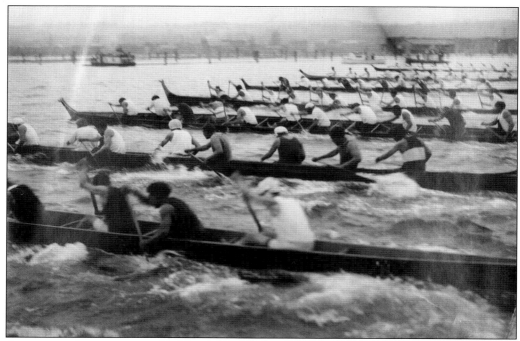

A canoe race between area tribes begins from the south beach of Cap Sante, heading across Fidalgo Bay. Races were a part of Independence Day celebrations here starting in 1890, occurring at this location as well as along cannery row on Guemes Channel. Among the frequent winners was *Telegraph*, built by Samish carvers Charles and Dick Edwards. The Samish tribe had a reputation for its skilled craftsmen. (Courtesy of the Anacortes Museum.)

Betty Lowman, one of Anacortes's "most colorful characters," swam from Anacortes to Guemes at age 14 and to Cypress a few years later. Her father, Ray Lowman, gifted Betty an unclaimed indigenous canoe with the admonition to be equal to the craftsmanship of its creator. After college graduation, Betty completed a 1,300-mile solo canoe trip to Ketchikan, where she caught up with her proud but concerned father. (Courtesy of Betty Lowman Carey.)

Four

TIMBER!

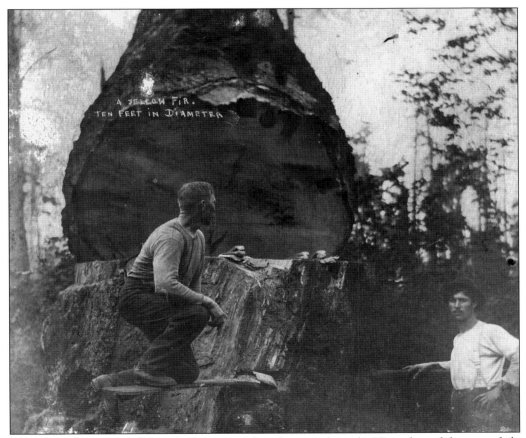

The original caption faded at the bottom of this photograph reads, "Snapshot of the tree while falling at Tyee Logging by J. H. Leballister, Anacortes, Wash. July, 1904." Metal saws and axes, combined with a desire for cleared land, created a rate of logging that far exceeded the selective techniques of the Samish and Swinomish. (Courtesy of the Anacortes Museum.)

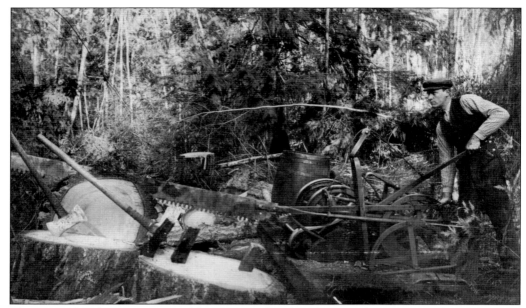

The gas engine drag saw increased logging speed and productivity beginning in the early 1900s, just as forests on Fidalgo Island were giving out. This local logger (around 1910) is bucking logs for cordwood, which might be used for home heating or to fuel a steam engine. (Courtesy of the Anacortes Museum.)

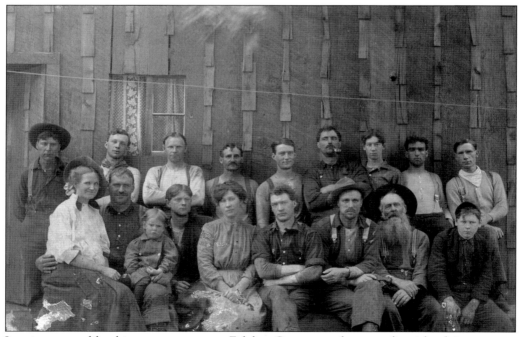

Logging camps like this one sprang up on Fidalgo, Guemes, and surrounding islands in response to timber demands from an increasing amount of area mills along Fidalgo Bay and at Deception. Not too many more years after this photograph was taken in about 1904, most of the harvestable forests on Fidalgo Island had been cut. (Courtesy of the Anacortes Museum.)

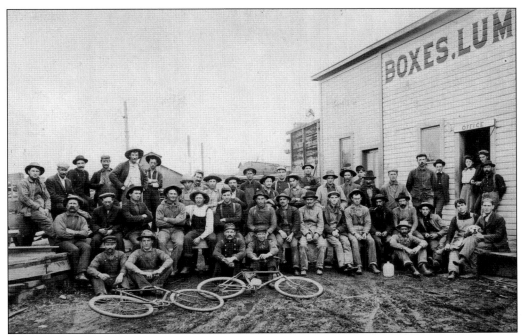

Anacortes Lumber and Box was the only lumber mill situated on Guemes Channel rather than Fidalgo Bay. In 1905, it renovated the Great Northern mill, which operated at Amos Bowman's first Anacortes mill site at the foot of T Avenue, dating back to 1882. In 1911, the Anacortes Lumber and Box Company claimed the title of the largest box manufacturer on the Pacific Coast, milling 25,000 feet of lumber daily. On the back of the original photograph seen above, Hugh Nelson is identified as "in back just left of window in a white sweater and hat" among the crew. Longshoremen are loading milled lumber below. The mill did not reopen after being destroyed by fire in 1941. (Below photograph by C. L. Judd; both courtesy of the Anacortes Museum.)

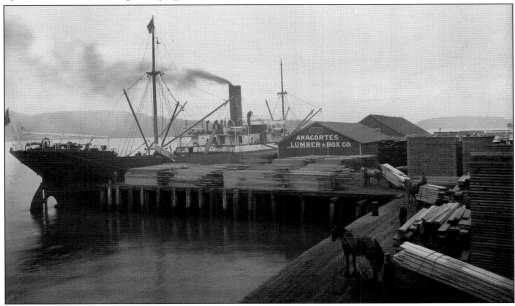

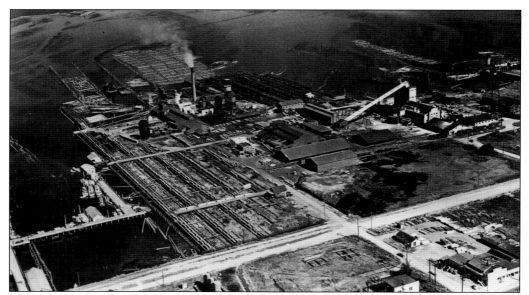

Scott Paper Company bought Anacortes Pulp in 1947, operating first under the name of its subsidiary, Coos Bay, until 1961, before operating as Scott Paper until closure in 1978. Immediately to the north is the old Morrison Mill and seine boats docked in the Cap Sante basin. At lower right, one can see Brown Lumber, located at the corner of Fifteenth Street and Commercial Avenue. (Courtesy of the Anacortes Museum.)

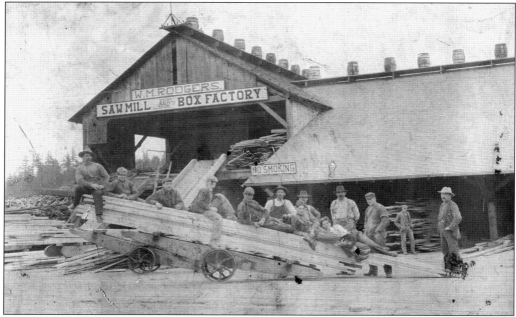

The Rodgers Sawmill and Box Factory was among the first on Fidalgo Bay, operating in Anacortes from 1894 to 1909 at the eastern foot of Sixteenth Street. This unidentified crew poses at the mill in 1909. Water-filled barrels on the roof served as an early sprinkler system in this fire-prone industry. In 1900, an angry mob surrounded the mill, threatening to run lower-wage Japanese workers out of town and block others from entering. (Courtesy of the Anacortes Museum.)

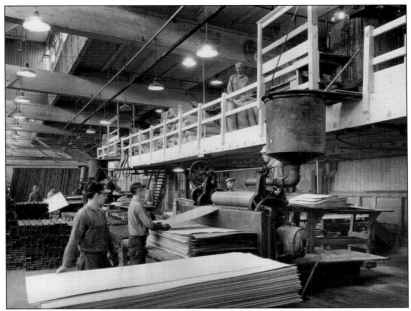

Located at the east end of Thirty-fourth Street on Fidalgo Bay, Anacortes Plywood formed in 1937 and began operating in 1939 as Anacortes Veneer, a worker-owned cooperative producing plywood sheets. Workers bought shares in the company and employed themselves as well as non-shareholders in meeting increased demand for plywood during the war years and beyond. After sheets of wood, known as veneer, are peeled from logs, the thin sheets are glued and pressed together before being sanded and cut to the standard 4-foot-by-8-foot size and in varied thickness. Twenty percent of jobs in Anacortes fell in the lumber category, making it the leading employer in town. The plywood mill was a steady local employer as Anacortes Veneer, then Publishers Incorporated, and as Custom Plywood until 1992 when the plant closed. (Both courtesy of the Anacortes Museum.)

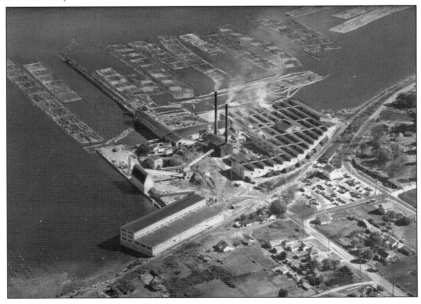

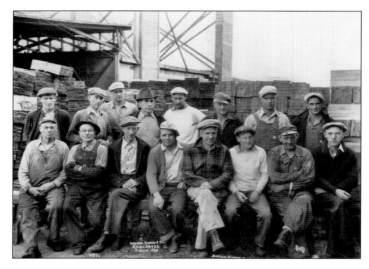

The Washington Shingle Company operated a cedar mill at Twenty-first Street on Fidalgo Bay between about 1934 and 1942. From left to right here in 1939 are (first row) unidentified, L. Gibbons, Chris Rickdall, unidentified, Robert Storer, and three unidentified; (second row) two unidentified, Raymond Rowell, Laurence Nasich, Don Mogenson, J. Mesford, Gene Gibbons, and unidentified. (Photograph by Darius Kinsey.)

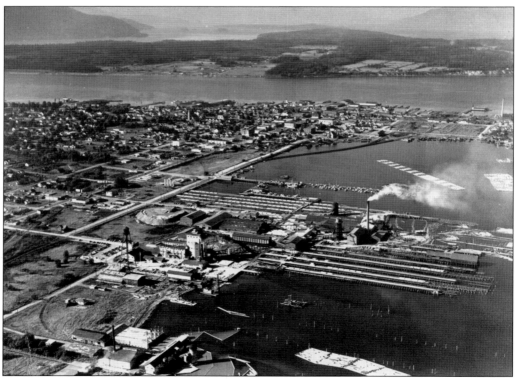

Anacortes was still very much a city of smokestacks in the 1950s. This aerial photograph from the south depicts the industrial activity along Anacortes's Fidalgo Bay shoreline. Below the stack (far right) of the defunct Anacortes Lumber and Box is the Little Chicago neighborhood of shanties and houseboats. Mills shown from the bottom up are Corbet Shingle Mill, Anacortes Pulp Company, and Morrison Mill. (Photograph by Glenn Davis.)

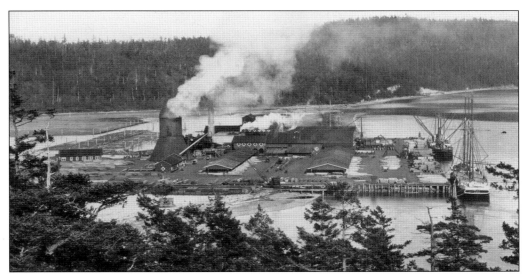

At present-day Skyline, Henry Havekost and the Northern Pacific Railroad built the Burrows Bay Hotel here in the 1890s. By 1914, Fred Wood had acquired the land for the largest mill on Fidalgo Island, which began sawing in 1923. The lagoon held thousands of logs, and a 1,500-foot dock fit three timber ships at once. The E. K. Wood mill sold to Walton in 1941 and closed in 1952. (Courtesy of the Anacortes Museum.)

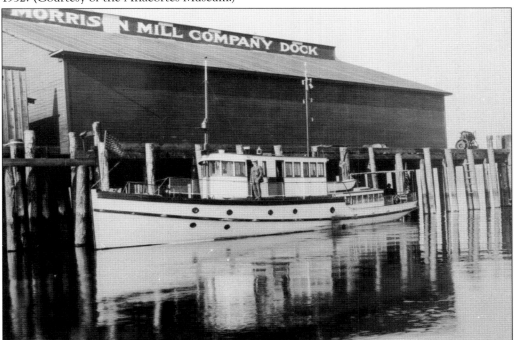

The passenger vessel *City of Anacortes* traveled from its namesake to Friday Harbor, Lopez, Port Stanley, Shoal Bay Quarry, and Bellingham, connecting with all daylight trains and steamers carrying passengers for the San Juan Islands. It was built in 1909 of Blakely Island timber on Decatur by Reed Shipyard for Kasch Navigation, and it was converted to an excursion boat. It went down in Alaska on May 8, 1933. (Courtesy of the Anacortes Museum.)

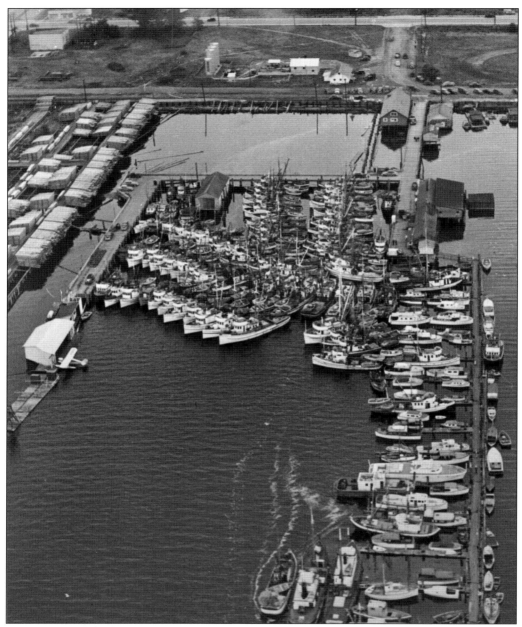

A fleet of nearly 100 purse seiners crowds the Cap Sante basin around the Shell dock in this 1949 aerial shot. Stacks of lumber line the shore (left) of the Morrison Mill property. Numbering nearly 20 seafood and wood plants, the lumber and fishing industries filled the entire downtown shoreline of Anacortes, other than the parkland of Cap Sante. While each industry's processing plants worked virtually side by side, logging destruction of salmon habitat contributed to the demise of Puget Sound's commercial fishery. (Courtesy of Arnold Moe.)

Five

FISHING AND CANNERIES

Ray Lowman (left) and his father, Will A. Lowman, hold a 72-pound spring Chinook salmon in 1914. This salmon very likely was caught in one of Will Lowman's several fish traps. Will started his first cannery, a clam cannery, in 1896 called the White Crest Cannery. Proceeds from this business enabled him to invest in a more lucrative salmon canning business, which he later renamed the Coast Fish Company. (Courtesy of the Anacortes Museum.)

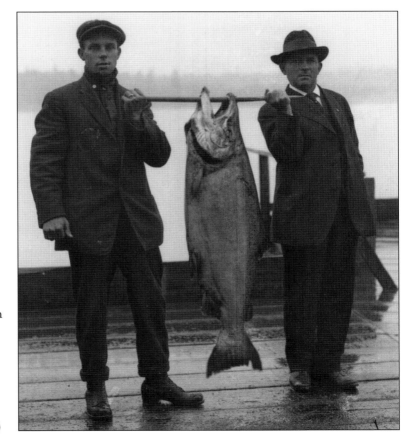

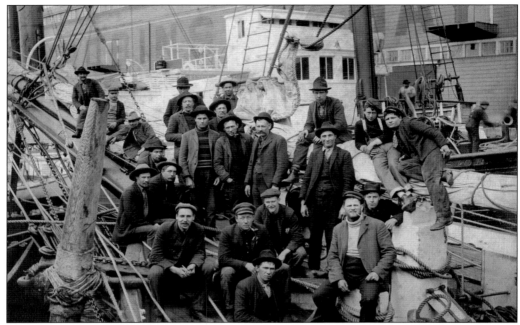

In 1891, J. A. Matheson brought schooners around the horn to start the Pacific cod fishery based in Anacortes. William Robinson originally operated a fish by-products plant before acquiring the *Alice*, *Joseph Russ*, and *Wawona* for the Bering Sea fishery. The two were most responsible for Anacortes being promoted as the "Gloucester of the Pacific," even importing cod fishermen (above) from New England, many of whom stayed on. The crew sailed each spring to Alaska's Bering Sea, using hand lines from solitary dories, catching fish one by one, returning to the schooner to clean and salt the catch, and doing this for three months before returning to Anacortes, where the cod was processed and shipped to market. Matheson Fisheries operated in Anacortes from 1891 to 1934. Robinson Fisheries operated from 1897 to 1948. (Both courtesy of the Anacortes Museum.)

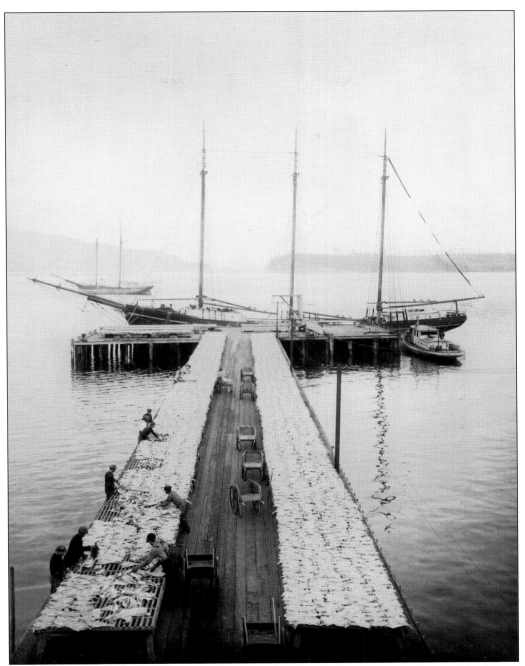

The *Wawona*, pictured here at the end of a dock full of cod drying on racks, was the largest three-masted schooner built in the United States. It was launched in San Francisco in 1897 and used to transport lumber from Northwest mills to the growing cities down the coast. In 1913, she was bought by Robinson Fisheries Company of Anacortes for use as a Bering Sea codfish boat, serving that purpose until 1947. (Courtesy of the Anacortes Museum.)

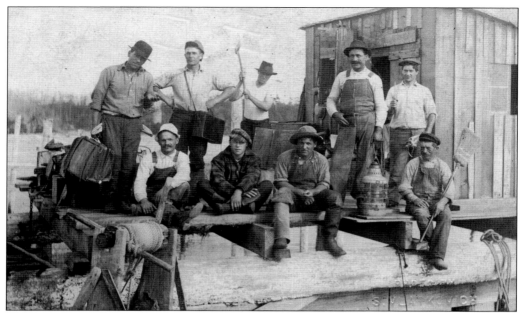

In the early days of Anacortes's salmon industry, canneries maintained their own fish traps along migratory routes. Once caught, salmon were kept alive in pens until needed before being transported to the cannery. From left to right are (first row) unidentified, Ernest Babarovich, unidentified, and Peter Babarovich; (second row) Mike Vulic, Frank Bozanich, two unidentified, and "Little Mike" Miscetich. (Photograph by S. Vlatkovich, courtesy of Phyllis Ennes.)

Fidalgo Island Packing Company pile driver crew and steam donkey hammer a fish trap in the San Juan Islands in 1912. Traps were put in on state-leased land in the spring, worked all summer, and taken out again in the fall. (Courtesy of Bill Mitchell.)

An unintended victim of fish trap nets, this beautiful orca is displayed as an awesome curiosity in this photograph taken in July 1914. Standing on the "killer whale" from left to right are Joe White, Joe Lancaster, Bert Butts, and Fred Fulton. Attitudes about orcas have changed dramatically in the past century. Thousands of tourists visit Anacortes each year to go whale watching. (Courtesy of the Anacortes Museum.)

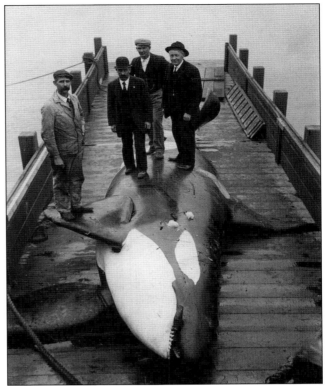

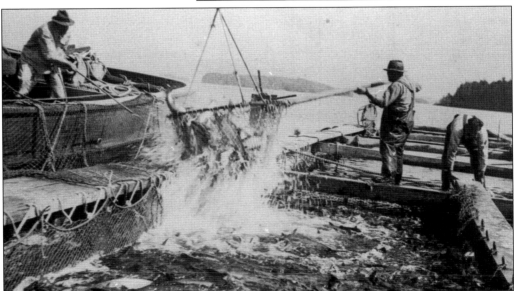

This crew is loading salmon onto a tender for delivery to one of Anacortes's canneries. Independent fishermen supplemented the catch of cannery-owned fish traps locally from 1894 until 1934, when traps were banned. Fish traps were used by local tribes in Padilla Bay, as reported by explorer Peter Puget. The new cannery traps sometimes displaced Native Americans from their traditional weir sites. (Courtesy of the Anacortes Museum.)

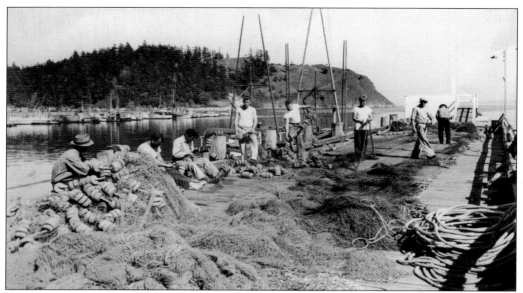

Before, during, and after the fishing season, sewing up holes and other net work was constantly required. The crew was expected to work on gear as part of their shared percentage of the total catch. The smart skippers would spring for lunch to keep up morale in this cooperative endeavor. Spanish cork floated the cork-line on top of the net, while lead-line weighted the bottom. (Courtesy of the Anacortes Museum.)

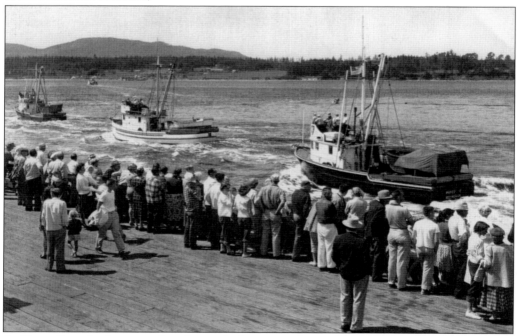

As Puget Sound salmon catches diminished, more and more local fishermen took their boats and crews to Alaska for months of fishing each summer, usually traveling in convoys. The fleet's departure was a community event, which included tearful farewells, last-minute maintenance, and a blessing from local clergy. (Courtesy of the Anacortes Museum.)

Exhausted by the labor-intensive salmon fishing on a purse seine boat, this crew takes a well-deserved rest from pulling the net onboard by hand. Clockwise from the winch are Dick Milat (holding cap), John Franulovich, Ray Separovich, Ivan Suryan, John Boravina, and Lino Dragovich in 1941 aboard the *Midnight Sun*. (Courtesy of Ivan Suryan.)

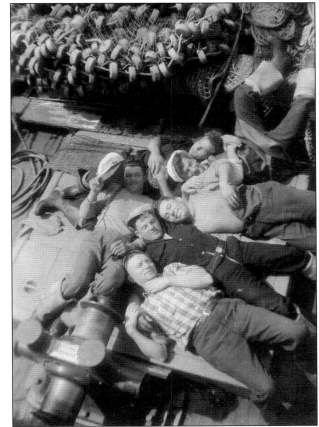

Still pulling the net in by hand in 1950, the crew of the *Sea Lassie* finishes a set in Rosario Strait. By 1954, the motorized pulley known as the Puretic Power Block greatly reduced the manpower necessary. From left to right are skipper Peter Maricich, Jack Kelley, Floyd Lunsford, Russ Childs, Merle ?, Dick Milat, Peter Padovan, and Jack Kamps.

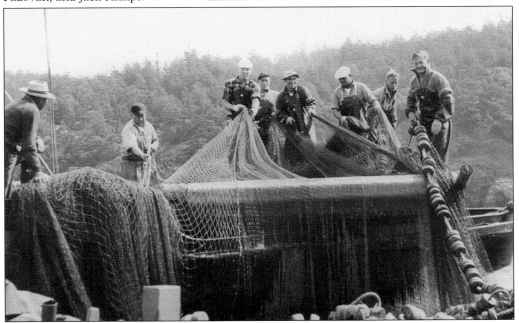

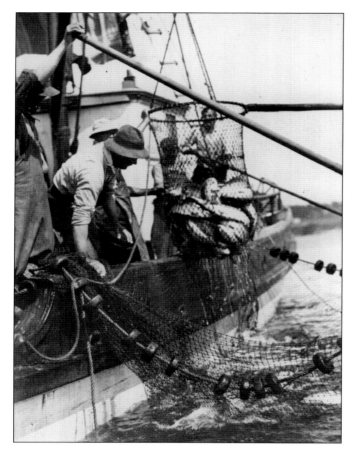

If the net is too full of fish, it can't be hauled onboard without first emptying some of the catch by means of a large dip net called a brailer. A winch and pulley help lift the salmon to the hold until the amount left in the purse is light enough that the web won't be torn when it is lifted out of the water. (Courtesy of the Anacortes Museum.)

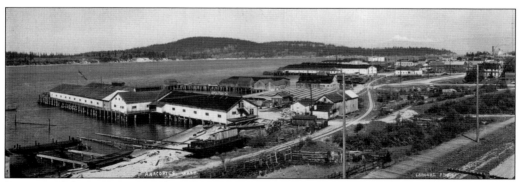

Up to 11 fish cannery sites dotted Anacortes's north shoreline beginning in the 1890s and enduring throughout the 20th century. In the foreground, the Apex Fish Company operated at the foot of J Avenue on Guemes Channel between 1898 and 1923, undergoing several changes in ownership. Cannery Row stretches eastward in this photograph toward the Porter Cannery, which became the cooperatively owned Fisherman's Packing Corporation in 1938. (Courtesy of the Anacortes Museum.)

This 1941 photograph shows Peter Maricich on the bridge of the *Sea Ranger*, with Pete Dragovich (future Anacortes police chief) on the port side and "Chupa" Barcott in front on the bow. The *Sea Ranger* was a cannery-owned purse seiner, contracted to productive skippers for a share of the catch. Advances in fishing technology like the power block and the drum are still years away.

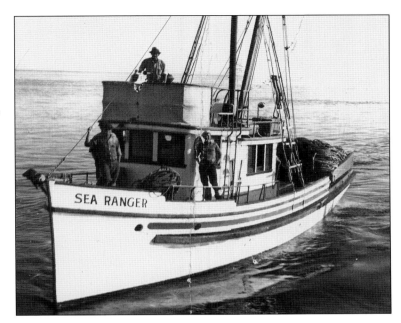

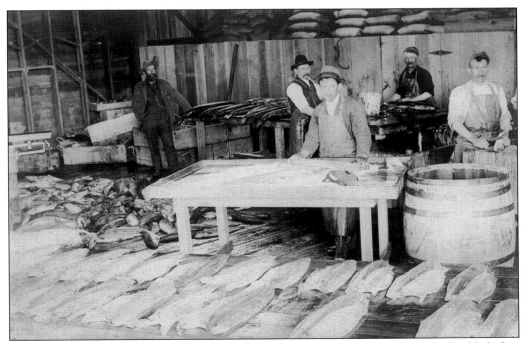

In this small-scale operation in 1900, large salmon are cleaned and filleted at the back table before being rinsed, salted, and readied for packing. Anacortes Canning Company offered salted and pickled salmon from their Ship Harbor location, near the present-day terminal of the Washington State Ferry. (Courtesy of the Anacortes Museum.)

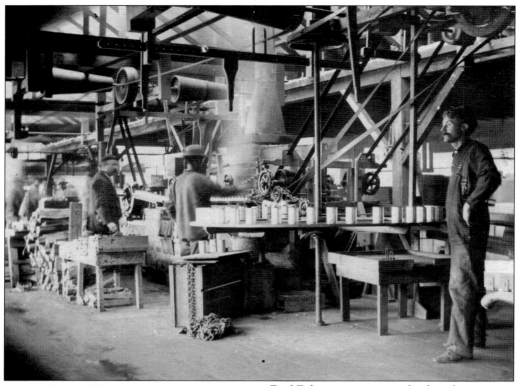

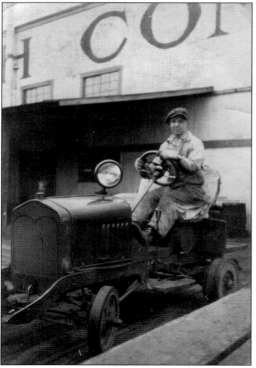

Fred Fulton was very involved in the town's canneries in the early days. He was one of the industry pioneers who advanced technology by inventing a can filling machine that achieved a rate of 120 cans per minute. Fulton (far right) managed the Porter Fish Company when this 1911 photograph was taken. (Courtesy of the Anacortes Museum.)

Joe Hagan is at the wheel of a Hood industrial tractor, which was able to haul over 8 tons of salmon cans pulled behind on carts. This 1918 photograph was taken on the dock of the Apex Fish Company. Several different owners operated the Apex between 1898 and 1928, when it was acquired by Pacific American Fisheries. Joe Hagan later became mayor of Anacortes from 1945 to 1952.

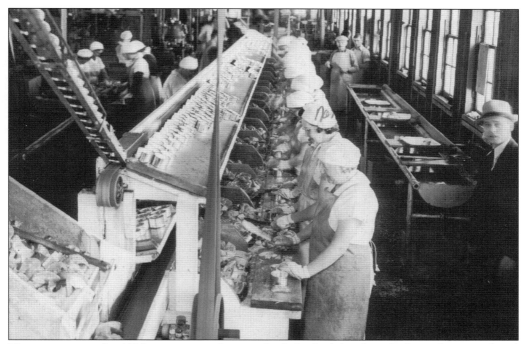

These women work a 1930s-era canning line, at which the fresh butchered salmon slices are placed into cans dropped via chutes from lofts above. The full cans are placed on a conveyer belt and directed to a can sealing machine. From there, the cans are cooked in large retorts and taken to the warehouse for off-season labeling. (Courtesy of the Rydberg family.)

Many a fisherman's daughter participated in the salmon harvest by working in canneries. From left to right are Anna Cepernich, Mary Gugich, Frances Barcott, and Millie Dragovich on the way to work in 1942. When the fish came in big, everyone worked. Shops closed as the town focused on processing the awesome harvest. The record year was 1913 when 39 million salmon were caught. (Courtesy of Fran Svornich.)

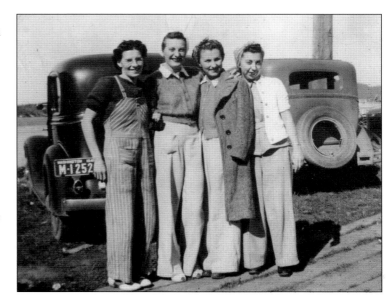

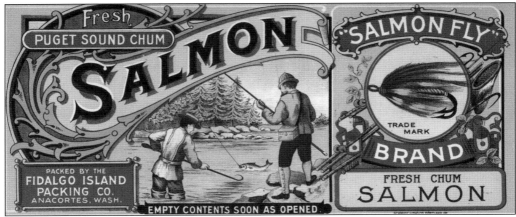

Fidalgo Island Packing Company began operations in 1894 at Ship Harbor, the current site of the Washington State Ferry Terminal in Anacortes. Beautifully colored labels such as this were designed to market the Puget Sound harvest internationally. Each cannery had many brands and labels. With the canneries now gone, the old labels have become collector's items. (Courtesy of the Anacortes Museum.)

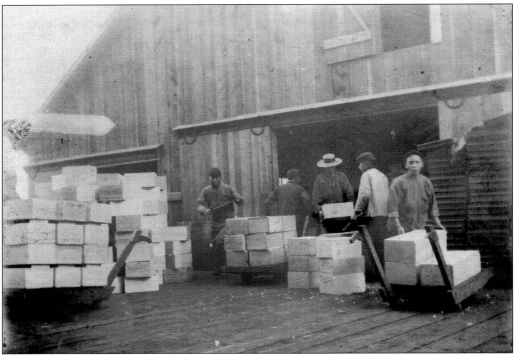

The 1903 invention by Edmund Smith of a salmon-gutting device, dubbed "Iron Chink," succeeded in the "unselfconscious racism" of his goal to reduce the need for Asian labor. Chinese workers are seen here packing crates labeled "Swan." Rarely did a seafood label actually read, "Packed by white labor only"; nonetheless, the local Chinese cannery workers were assigned jobs that prevented them from contacting the flesh of salmon in the early decades. (Courtesy of the Anacortes Museum.)

As the supplier of Chinese laborers to local canneries, Seid Chee (1865–1942) was allowed "privileges" like living with his wife and family at 1311 Fourth Street. From left to right on the porch of his home are On Kum carrying baby Seid Oy ("Rose" in English, after the local theater), Seid Chee, and Seid Wa Yut in about 1911. Tong wars among workers compelled Seid to employ Herman Horsey as a bodyguard. (Courtesy of the Anacortes Museum.)

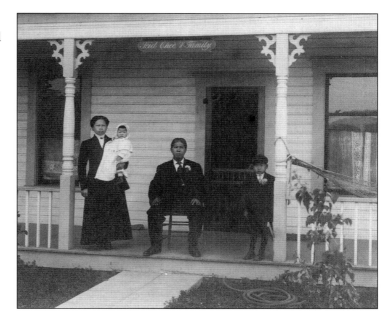

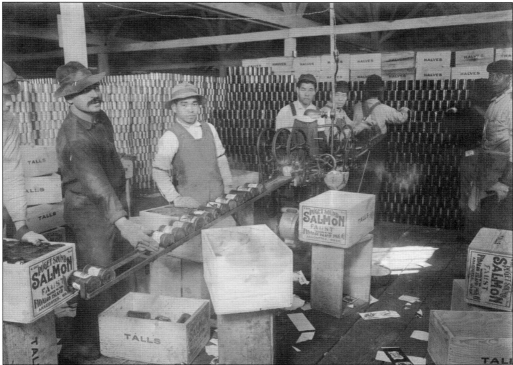

The many Anacortes canneries employed hundreds of white, Native American, Chinese, and Japanese workers, but they were treated far from equally in this racist era that saw whites forming an "Anti-Mongolian League." The Chinese Exclusion Act of 1882 barred new immigration and prevented naturalization for those already here. This prejudice kept them segregated at work and isolated from the community in "China Houses." (Courtesy of the Anacortes Museum.)

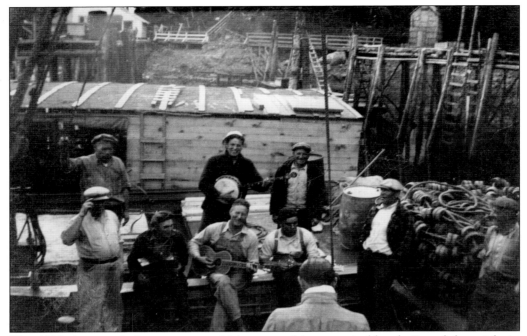

This 1938 photograph shows a group of fishermen taking a musical break. From left to right in the first row are unidentified, Pete Gugich (accordion), two unidentified, and Steve Cupic; the rest are unidentified; (Courtesy of Linda Gugich Holmes.)

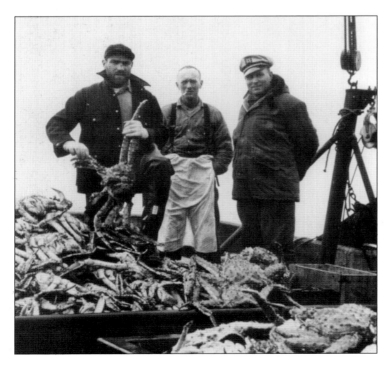

While the King Crab fishery in Alaska began in the 1930s, substantial commercial crabbing didn't take off until the 1950s. These Anacortes fisherman—from left to right, Vito Ruzich, Clayton Hove, and George Franulovich along with (photographer not pictured) Branko Jurkovich—pioneered the industry that has come to be known as "the Deadliest Catch." (Courtesy of Branko Jurkovich.)

Six

GETTING AROUND TOWN

D. B. Ewing photographed Fred White and his new safety bike at the height of the national bicycle craze. This picture inspired the first of many murals in the Anacortes Mural Project. The mural of Fred White is located on the Demopouloses' Marine Supply building, at 202 Commercial Avenue, near a new bicycle-friendly ramp. (Courtesy of the Anacortes Mural Project.)

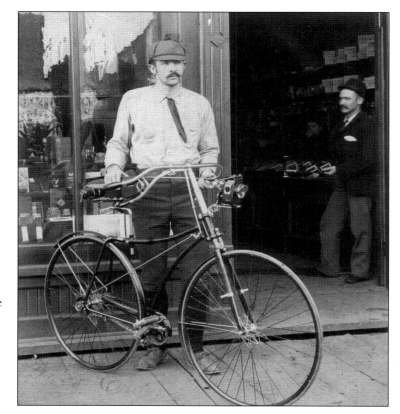

Taken a few years before Anacortes passed its 1904 livestock law, this reclining rider atop a mule conveys a relaxed message amid the hard labor required by frontier life on Anacortes's waterfront. Like most Puget Sound seashore towns, activity in Anacortes centered on or at the water's edge, slowly pushing inland to meet rail lines and roadways. (Courtesy of the Anacortes Museum.)

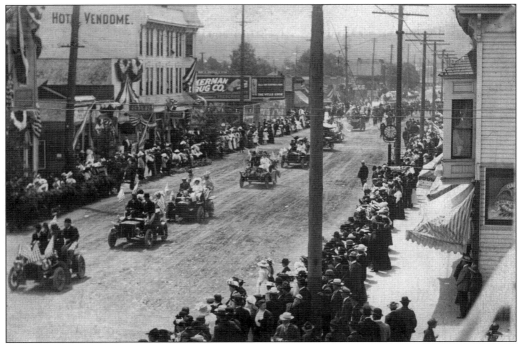

This view looks south down Commercial Avenue, taken from Fifth Street. Of the 3,611 license plates issued in Washington in 1909, sixteen were in Anacortes; that year's Fourth of July parade featured most of the town's vehicles. The second-floor bay window to the far right is directly above McCracken's Rainier Bar, seen earlier in this book. (Courtesy of Bill Mitchell.)

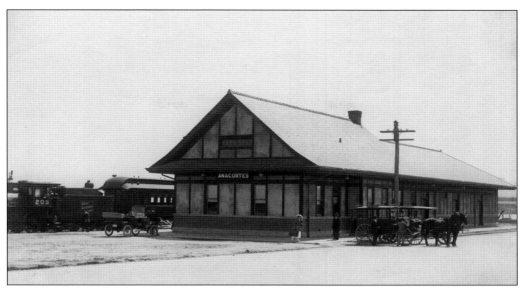

The "new" Great Northern Depot was built in 1911 at Seventh Street; here the Hotel Taylor hack competes with an automobile "for hire." The Seattle and Northern Railroad Company ran the first passenger train to Anacortes on August 5, 1890, stopping at the depot located near Ninth Street and N Avenue. Northern Pacific built its depot later that year at Sixth Street and I Avenue. (Courtesy of the Anacortes Museum.)

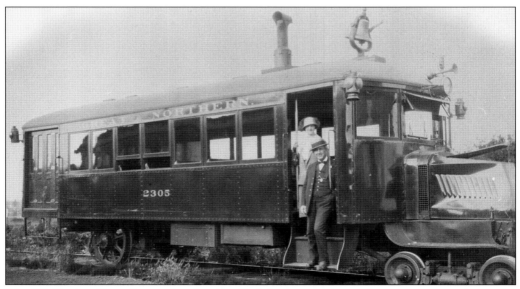

The "Galloping Goose" was what locals called the one-car interurban passenger train on the Great Northern line that connected Anacortes to the "real" train in Mount Vernon. This 33-passenger "motorbus" only required a driver and conductor; it began operating in 1922 after the train was taken off the route and continued into the 1930s, when automobile use diminished train ridership.

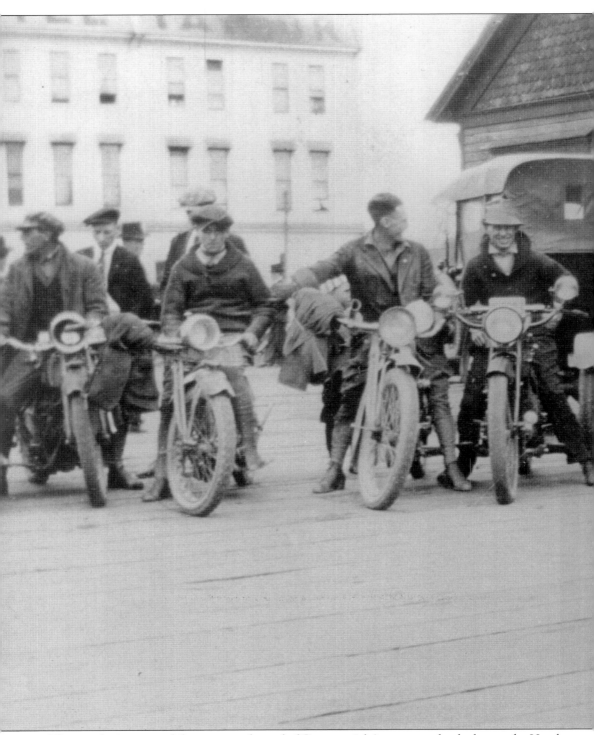

These early Anacortes bikers pose at the end of Commercial Avenue, on the dock near the Hotel Taylor. This gathering is perhaps a precursor to today's Oyster Run, which attracts thousands of

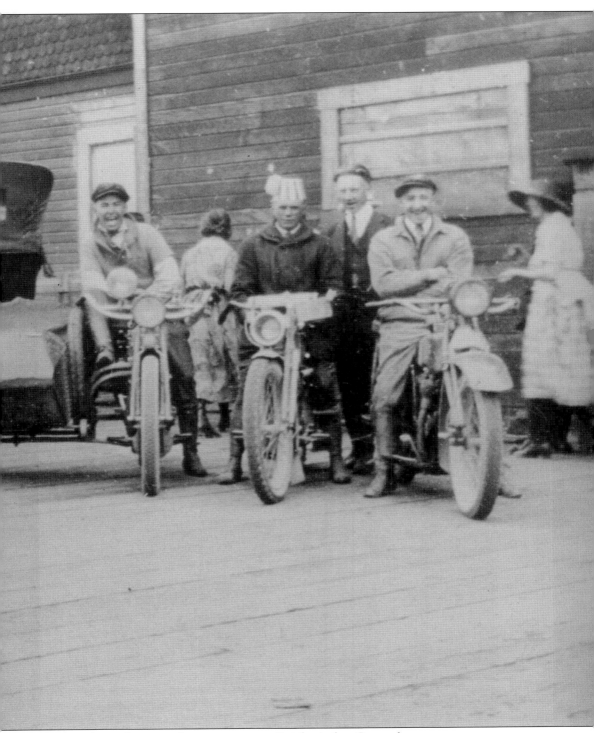

motorcycles each year to Anacortes on one Sunday in late September.

Posing here in front of the rectory, Fr. Gustave Truenet was the first resident priest in Anacortes, who arrived from France via Nova Scotia in 1910. He had degrees in law and medicine from the Sorbonne before opting for the priesthood. Upon arrival, he immediately organized construction of a new church basement, named Joan of Arc Hall, atop which the new church was built in 1929. (Courtesy of the Barcott family.)

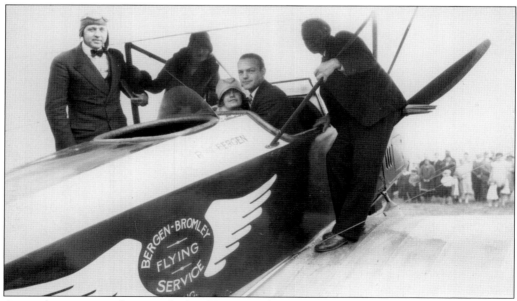

An airplane marriage between Richard Fenno and Minnie Kirkman was part of the inauguration of the airfield at March Point in 1928. The Kiwanis Club leased land from Fred March to build a 2,000-foot airstrip after a yearlong fund drive by the Anacortes Civic Club. Some 10,000 spectators attended as planes flew in from around the region. (Photograph by Ferd Brady, courtesy of the Anacortes Museum.)

A horse-drawn carriage approaches the intersection with Seventh Street on Commercial Avenue, while an early car just enters the picture. Men, women, and children are out with their hats on. E. W. Moyer's new building (1910) stands at right. An elk head on the Moyer Building denotes the BPOE's occupancy on the top-floor ballroom on Seventh and Commercial. (Courtesy of Maria Papritz.)

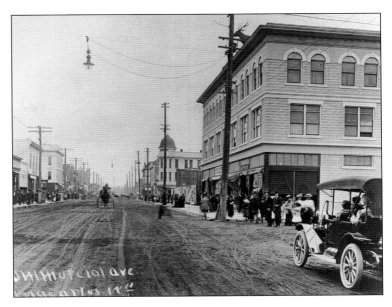

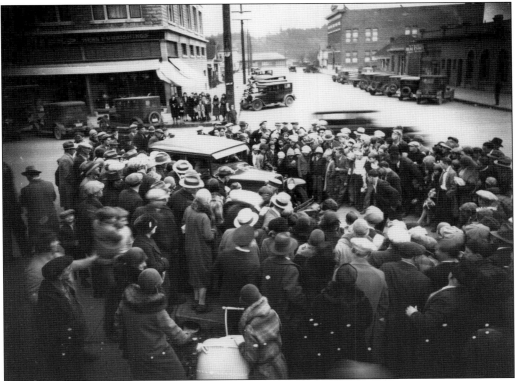

A crowd has gathered as a movie lets out of the Empire Theater on Seventh Street and Commercial Avenue to check the condition of a pedestrian, whose head is visible as he reclines under the stopped automobile. Moyer's is offering Men's Furnishings across the street, and the Eagles Hall and Great Northern Depot are visible down Seventh Street. (Photograph by Ferd Brady, courtesy of the Anacortes Museum.)

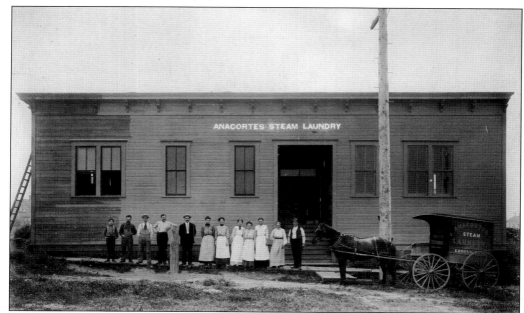

Established in 1898, the Anacortes Steam Laundry moved to its Third Street and N Avenue location after being purchased by Hugo and Theodore Erholm in 1905. A steam engine, fueled by 4-foot lengths of slab wood, powered the washers and wringers. The business operated until 1966, and the building burned in 1986. (Courtesy of the Anacortes Museum.)

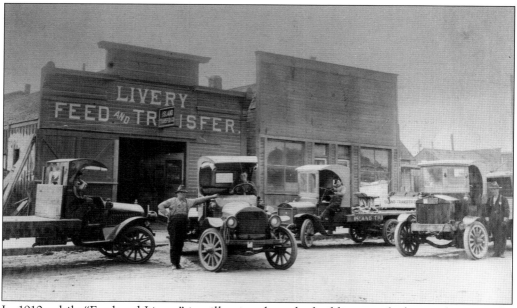

In 1910, while "Feed and Livery" is still painted on the building, trucks have taken over for horsepower at the Mondhan's Island Transfer Company at 907 Third Street, eliminating the need for the blacksmith shop formerly located next door. Island Transfer advertised "local and long distance hauling" with "prompt and careful service at reasonable rates," even going so far as "call us day or night." (Courtesy of the Anacortes Museum.)

Shown here at the wheel of his Mack truck is Efthemios "Mike" Demopoulos, who left Greece in 1906 and came to Anacortes soon thereafter. He borrowed $14 and created Anacortes Junk Company on Second Street, expanding his business to marine supply. As a pioneer recycler, he advanced from a wheelbarrow to become a millionaire by investing in Anacortes real estate. (Courtesy of the Demopoulos family.)

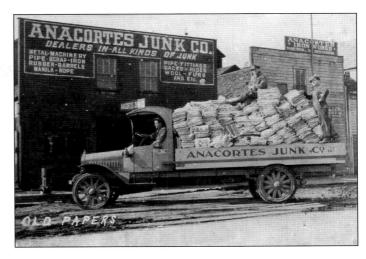

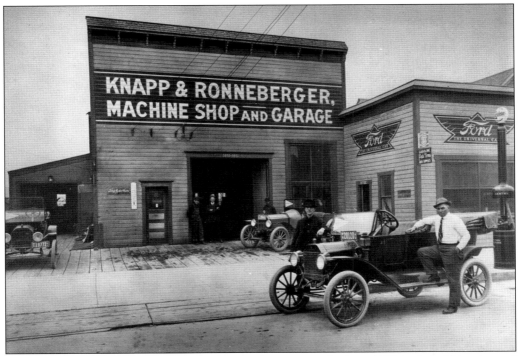

In 1900, Ed Knapp operated a bicycle shop in Anacortes, which in 1905 included bicycles and "machinists." Knapp (center) had the first car in town, a 1903 Conrad. In 1907, he teamed with Ben Ronnenberger (right) to start the third Ford dealership in Washington. Their garage located on Sixth Street had engines under the floor to power shop tools with overhead shafts and pulleys. (Courtesy of the Anacortes Museum.)

In 1903, Melville Curtis built the Curtis Wharf at the foot of O Avenue. The Anacortes Ice Company established there in 1906, conducting a versatile business in coal, hay and feed, dairy products, soda bottling, and wholesale meats. From left to right (above) are Charlie Stokes, Lee Neely, and Bill Charlot standing beside two Model Ts and a Mack truck advertising Cypress Island spring water. Glenn Bliss (below) was a driver for the company in 1922, delivering Skagit Maid Ice Cream in barrels on the back; the truck advertises Whistle soda water and Albers flour and feed. (Both courtesy of the McCracken family.)

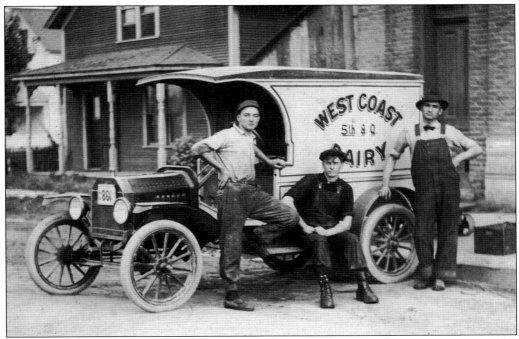

The West Coast Dairy, manufacturers of ice cream and Golden West Butter, operated at Fifth Street and Q Avenue on the ground floor of the Semar building. This 1915 truck delivered milk and eggs to Anacortes homes at a time when Fidalgo Island's farmers provided for many of Anacortes's needs. From left to right are milkmen Ed Brado, Cliff Bessner, and Joe Mears. (Courtesy of the Anacortes Museum.)

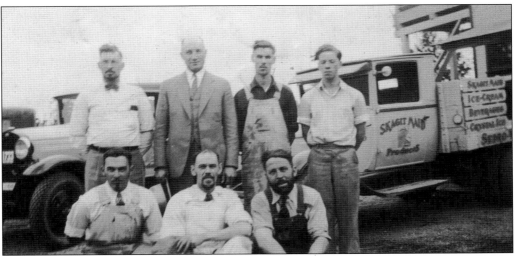

Posing next to a Skagit Maid delivery truck is Bill McCracken (in suit) with the crew of the Anacortes Ice Company, which he operated. Bill's father, Frank McCracken, settled in Anacortes after prospecting elsewhere, opening the Eureka Club at the northwest corner of Fourth Street and Commercial Avenue. The family home was at 1014 Fourth Street. (Courtesy of the McCracken family.)

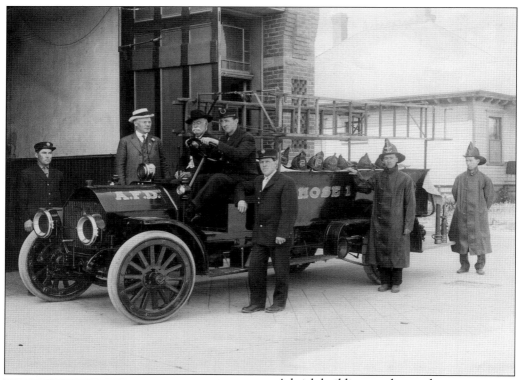

A brick building on the southwest corner of Fifth Street and O Avenue housed both the Anacortes Fire Department and city hall beginning in 1892. The 1914 photograph above shows mustached Mayor Frank Hogan in the passenger seat; the ex-Confederate soldier was elected to head the first city government in 1891. He returned for two more terms in 1904 and 1915. The building exterior is visible to the left with firemen, from left to right, Stan Mondhan, Bert Verral, Mike Strock, and Chief Les Snyder. This old fire hall was demolished soon after a new fire station was constructed at 1011 Twelfth Street in 1953. (Both courtesy of the Anacortes Museum.)

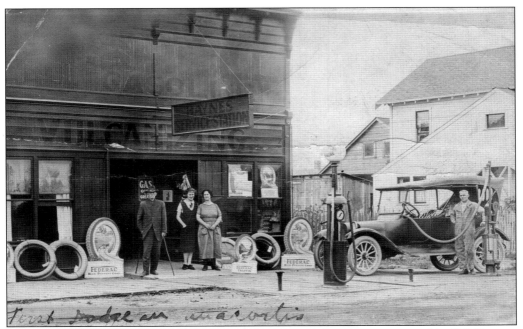

This gas station at Twenty-second Street and Commercial Avenue was operated by Bill Haynes, standing next to one of the first Dodges in town. In addition to vulcanizing, Haynes advertised Shell gasoline. By the time Prohibition ended, the station was selling Gilmore Red Lion gas as well as beer. The tavern outlasted the service station, enduring under various owners through nearly the end of the century. (Courtesy of the Anacortes Museum.)

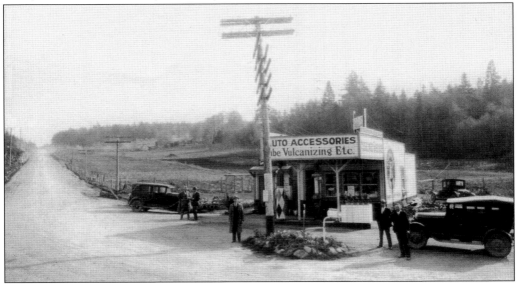

In 1924, Charles Dean built a service station at the end of Fidalgo Bay, where westbound Highway 20 forks and leads to Anacortes or Whidbey Island. From that point until the 1950s, the intersection was referred to as "Dean's Corner." Expansion included a garage, groceries, and cabins. In 1949, Sharpe's Service opened across the road, and the common use of the name "Sharpe's Corner" occurred over time. (Courtesy of the Anacortes Museum.)

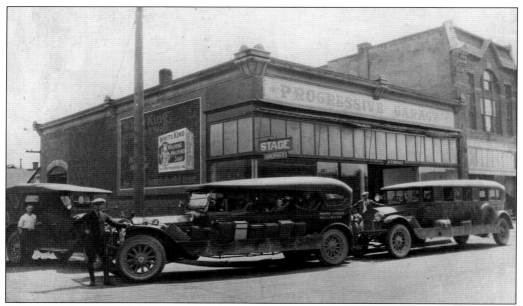

Located on Commercial Avenue at Eighth Street, the Progressive Garage served as the stage depot in Anacortes in the early 1920s. Run by Myron "Mike" Kidder in partnership with attorney Ben Driftmeyer, it was the first registered bus line in the state, with daily trips to Mount Vernon and routes around town. It also served as a newspaper distributor, perhaps as cover for its rumored bootleg booze sales during Prohibition. The business was sold to Affleck Brothers after Myron's death in 1924. (Courtesy of the Anacortes Museum.)

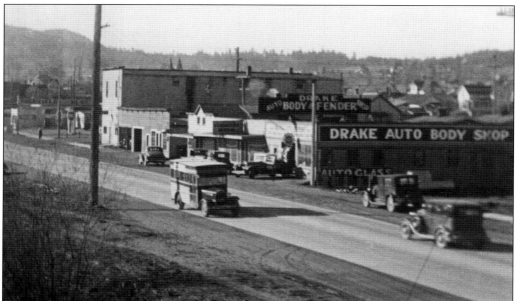

The jitney served the south side bus line, bringing residents of south Anacortes (formerly the Nelson Addition) to downtown stores and jobs. In this photograph, the jitney is making a morning run northbound on Commercial Avenue in front of Drake's Auto Body Shop at Sixteenth Street. Bill Bessner purchased the bus line in 1929. (Courtesy of the Anacortes Museum.)

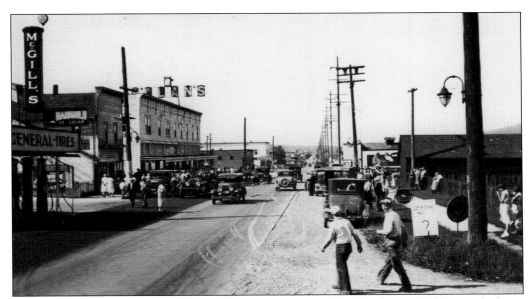

Looking north on Commercial Avenue from Twenty-second Street, this 1941 photograph shows a bustling south side of Anacortes, with McGill's Service Station in the foreground and another Allan's Market located at 2104 Commercial. In the distance is a service station at Eighteenth Street. In this era, people in town were likely to stay in their neighborhood for shopping and socializing. (Photograph by Ferd Brady, courtesy of the Anacortes Museum.)

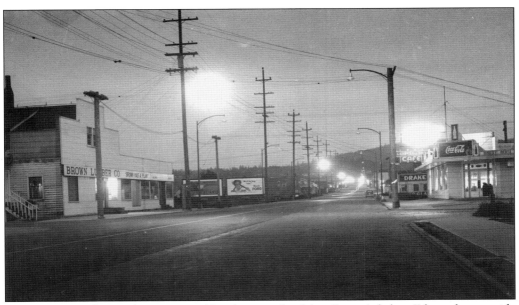

The Brown Lumber yard was operated by photographer Matt Brown's father, Ed, on the east side of Commercial Avenue at Fifteenth Street. Across Commercial is Dybbros Grocery, which opened in 1941. This rare night shot looks toward the city's "South Side" as Commercial Avenue stretches toward the highway out of town. The jitney photograph from the previous page was taken from the roof of Brown Lumber. (Courtesy of the Anacortes Museum.)

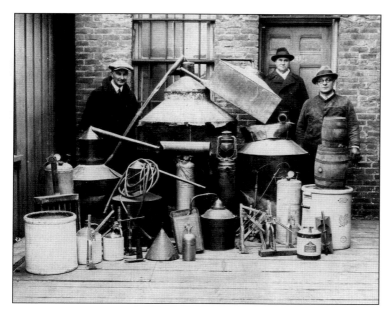

Washington State went "dry" in 1916, four years in advance of the Volstead Act prohibiting liquor nationally. During Prohibition, local stills quenched the demand for illegal booze that wasn't met by smuggled Canadian imports. Posing in 1925 with a confiscated still in front of the city jail are, from left to right, unidentified, policeman Tom March, and police chief Al Sellentin. (Courtesy of the Anacortes Museum.)

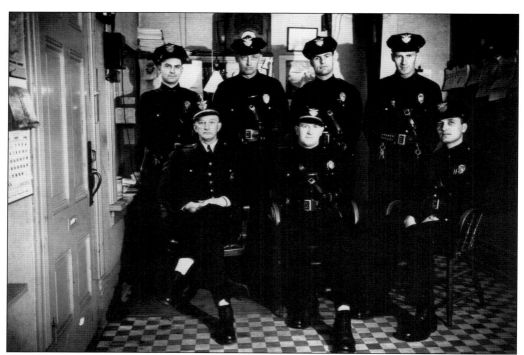

In 1936, the Anacortes Police Department was located at city hall, 1107 Fifth Street. By 1927, the Anacortes force was wearing uniforms, responding to concerns that out-of-towners wouldn't know who they were. From left to right are (first row) Chief Harold Hinshaw, Tom Brown, and Nick Petrish; (second row) Merle Iverson, Lawrence Pollard, J. B. Goff, and Martin Beebe. (Photograph by Ferd Brady, courtesy of the Anacortes Museum.)

Carl Christensen (left) and John Tursi are pictured here as part of the Civilian Conservation Corps, a Great Depression–era work program that brought Tursi from the streets of New York to Deception Pass State Park. CCC crews constructed roads and buildings, and many stayed on in Anacortes afterward. Tursi's *Long Journey to the Rose Garden* is a must read for local history. (Courtesy of the Anacortes Museum.)

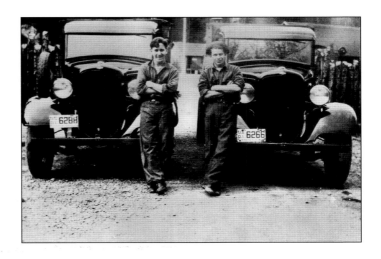

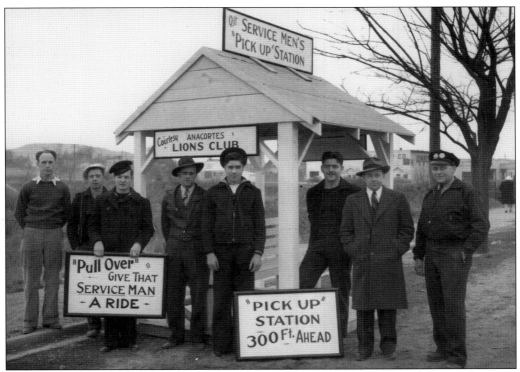

World War II brought many servicemen to Anacortes, with soldiers barracked at the Community Building, Coast Guardsmen on the waterfront, and the Whidbey Naval Air Station only a few miles away. All of the military personnel combined with fuel rationing led to the patriotic and resourceful idea of the local Lions Club to build a pickup site for hitching troops. (Photograph by Ferd Brady, courtesy of the Anacortes Museum.)

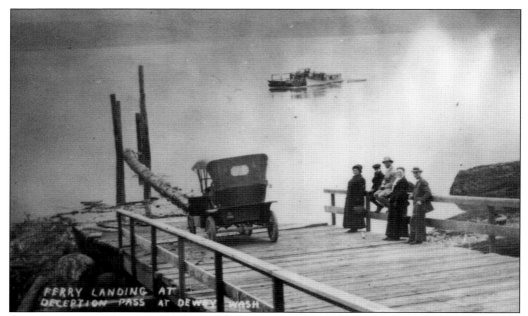

Auto ferry service between Fidalgo's Yokeko Point and Whidbey Island was begun in 1913 by Cornet Bay postmaster Fred Finson, who towed a barge capable of holding four cars. Berte Olson ran the ferry and promoted local tourism with her husband, Augie, after buying the ferry in 1920. In 1922, they had a new ferry built. The 64-foot *Deception Pass* held a dozen Model Ts, but bridge construction doomed the Olsons' business. (Courtesy of the Anacortes Museum.)

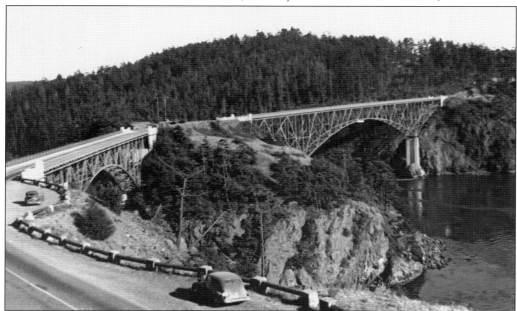

The Deception Pass Bridge connects Fidalgo Island to tiny Pass Island and Pass Island to Whidbey Island. It is the only road off of Whidbey Island and in 2007 was crossed by over 15,000 vehicles per day. Other routes off Whidbey are by ferry to Port Townsend or Mukilteo. A ferry from Fidalgo Island to Whidbey's Hoypus Point did not run long after the bridge completion in 1935.

Seven

GIVE ME AN "A"

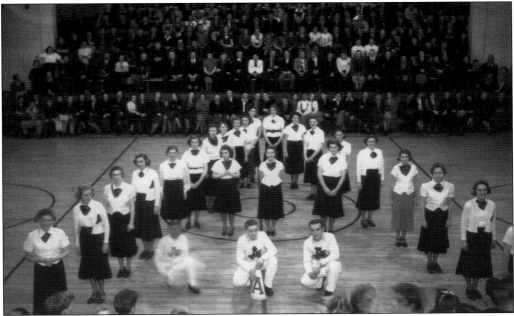

Local sporting events and school performances provided some of the best, and often the only, entertainment available in the era before television. Anacortes had many schools over the decades, including the Alden Academy, which opened in 1879 in the vicinity of Thirty-second Street and Heart Lake Road, the Nelson School at Twenty-ninth Street, the Columbian School, and also the Dobers School, the old Whitney School. Cheerleaders, pictured here in the old high school gym, form the letter "A" to cheer on the purple and white. (Photograph by Ferd Brady, courtesy of the Anacortes Museum.)

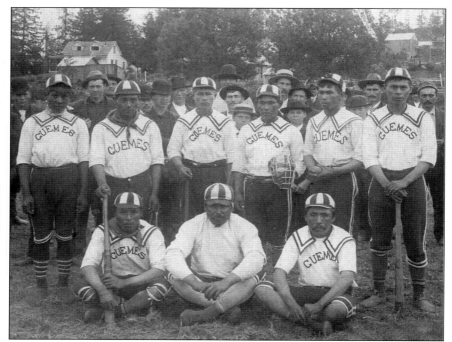

These Samish men (above) are suited up for a Guemes Island baseball team around 1900. Long before baseball arrived, a summertime sport called "Shinny," described in *The Indians of Puget Sound*, was played in this region between tribal teams on beaches or prairies using a baseball-sized ball and wooden sticks. During the first decades of the 20th century, a baseball field (below) was maintained near the Rodgers Lumber Mill, at approximately Seventeenth Street and R Avenue. Several mills fielded teams, but shingle mill crews were, according to lore, less likely to play ball because of a higher amount of finger loss on the job. (Above, photograph by Booen and Ewing, courtesy of the Samish Indian Nation; below, the Anacortes Museum.)

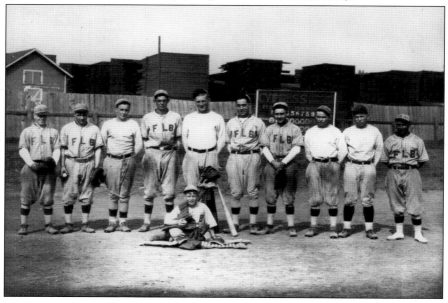

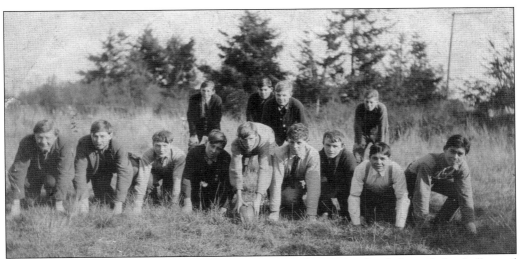

Looking as if they play football in the forest, the 1913 Nelson School eighth-grade football squad lines up at the scrimmage line. The names listed on the back of the original, in unconfirmed order, are Howard Kellogg, Gene Butts, Earl Lane, John Mount, John O'Day, Wallace Jones, Herbert Hendel, Ora Hamilton, Harold Kellogg, Dewey Mondhan, Walth Mitchell, Billie Beal, and Henry Stackus. (Courtesy of the Anacortes Mural Project.)

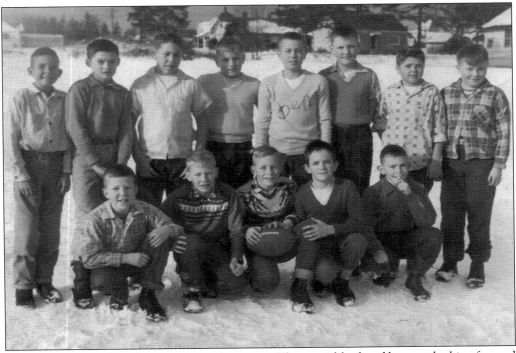

Everything is more fun when it snows in Anacortes. These neighborhood boys are looking forward to a game of football in the white stuff. Games between neighborhood teams, like the downtown kids playing their south side rivals, are fondly remembered. (Courtesy of the Rydberg family.)

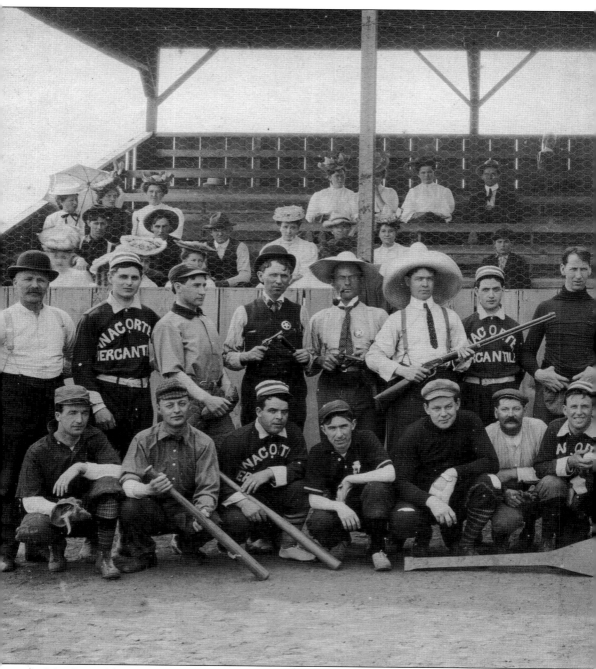

Members of the Anacortes Mercantile baseball team are scattered throughout this 1904 photograph capturing participants in a game between the Bachelors and the Married Men. The painted paddle reads, "The bachelors have some experience with 'bawls' coming." Posing from left to right in the

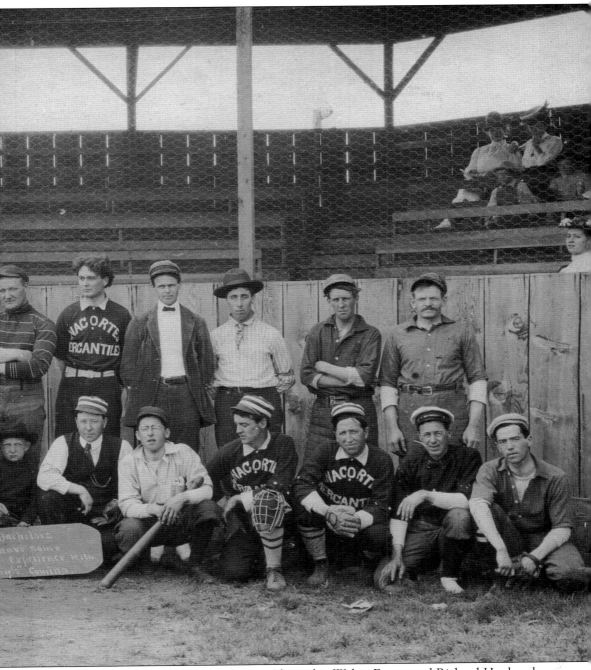

first row are Tom Benn, unidentified, Ivan Alexander, Walter Foster, and Richard Hardcastle; the rest are unidentified, except for Mayor H. H. Soule, who is in the derby hat to the far left in the top row. (Courtesy of the Anacortes Museum.)

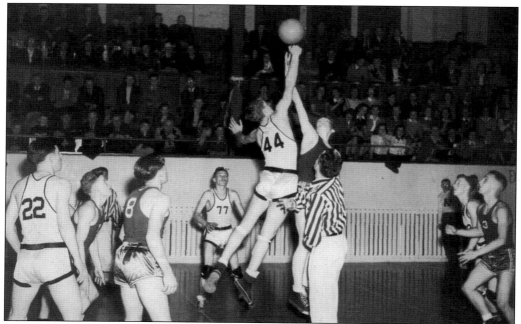

The star center of coach Richard Wooten's team in the early 1940s, Irv Rydberg wins the tip against Anacortes's rival, Mount Vernon. The gym at the old high school would fill to capacity hours before each game during the years of an Anacortes basketball dynasty. Rydberg returned to Anacortes following service and college to run a recreation program for local kids before becoming a school principal. (Courtesy of the Rydberg family.)

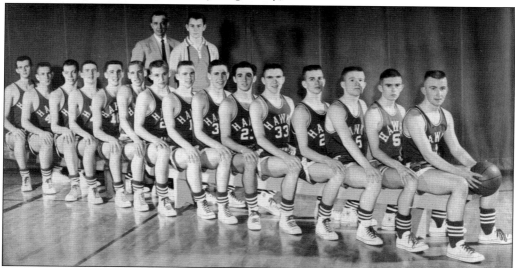

In 15 years as Anacortes's basketball coach, Bill Taylor posted a record of 202 wins and only 59 losses, with state-placing teams that twice achieved second place in the state tournament; this 1960 team placed third. From left to right are (seated) Bob Pearson, Jim Spitze, Bob Evans, Paul Webber, Joe Maricich, Sid Clarke, Gary Erholm, Kent Ashworth, Fred Crowell, George Cherry, Ken Moore, Butch Balthazor, Terry Toland, Brian Rockom, and Ralph Cole; (standing) coach Bill Taylor and manager Tom Hoots.

Anacortes's 1925 girls basketball team from left to right are (top row) C. Landsborough, coach Mary Kasch, Dorothea Pollock; (middle row) Vesta Mulberg, Alice Hamilton, Ethel Cartwright, Marjorie Wilson; (bottom row) L. G. Jordan, Martha Shannon, and Dorothy Jordan. The following accompanied this photograph in the 1925 yearbook *Rhododendron*: "We feel that the few months of basketball have shown us the way to a higher and cleaner life."

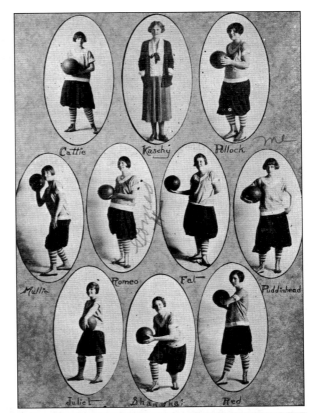

While the football team went undefeated, the 1929 Anacortes High basketball team was not particularly accomplished. On its roster was future coaching legend and grandson of Anacortes pioneers, Richard "Boots" Wooten, who is to the far right in the first row. From left to right are (first row) Moe, Boulton, Olson, and Wooten; (second row) Hemingson, Arnott, Morin, Hill, Martin, Asseln, and coach Harold "Pop" Keeney.

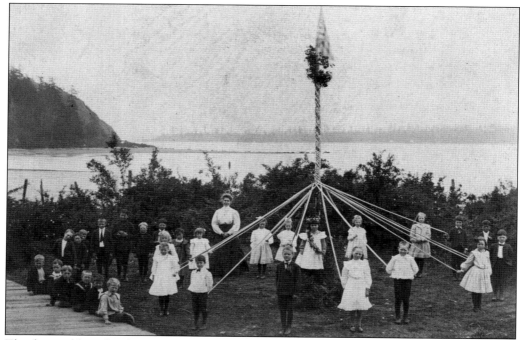

The first public school in Anacortes was started in 1875 in an abandoned shack with seven pupils from the Wooten and Beale families near Thirty-fifth Street and T Avenue. It was moved to the Tom Lamb Building three years later. In this turn-of-the-20th-century maypole photograph, notice how far the beach below Cap Sante stretches into Fidalgo Bay. (Courtesy of the Anacortes Museum.)

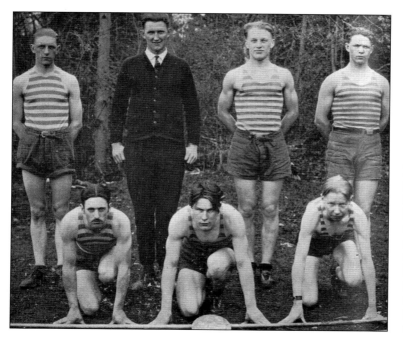

Ready to win the race for Anacortes High School are, from left to right, (first row) Farrell, Moffett, and Kasch; (second row) Krueger, coach Black, Shannon (who placed first in shot put and javelin at the 1924 county meet), and Moe.

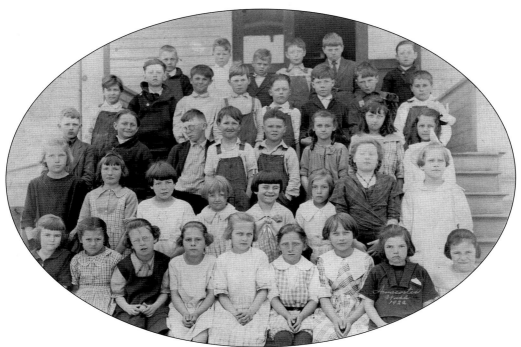

A 1922 photograph shows the class of 1931 as third graders. From left to right are (first row) Helen Webb, Merle Cummings, Marivere Harris, Lucille Bozanich, Flo Breslich, two unidentified, Margaret Deane, and unidentified; (second row) Thyra Theurane, Rachel ?, Betty Lowman, Mary Wollertz, Kathyrn Worth, Louise Suryan, unidentified teacher, and Dorothy Holman; (third row) unidentified, Paul Franulovich, two unidentified, ? Andrich, two unidentified, and Stacy Wilson; (fourth row) Raymond Horsey, Elston Smith, Bob Trafton, five unidentified; (fifth row) Waldo Olson, Larry March, Leo Hemingson, and three unidentified.

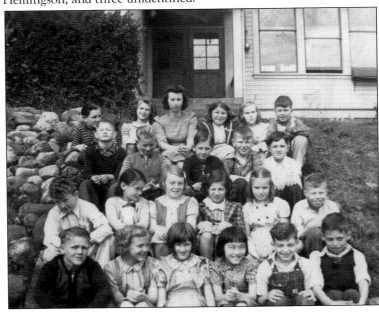

This class of 1949 posing in front of Whitney School (around 1939) contained several children of immigrants. The Japanese girl in the first row was likely sent to an internment camp following Roosevelt's executive order after Japan's attack on Pearl Harbor. Author Agnes Rands writes about the war years in Anacortes in her book *Even Seagulls Cry.*

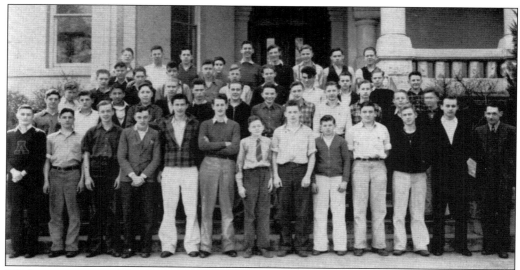

While every name and face has a story in this 1939 portrait of Anacortes's freshmen, the eye is drawn to the scrawny kid in the middle of the first row. Harry Smith left Anacortes before graduating to pursue a varied "career" as an artist, filmmaker, and ethnographer. His *Anthology of American Folk Music* earned him a Grammy and is credited as the bible of the folk revival of the 1960s.

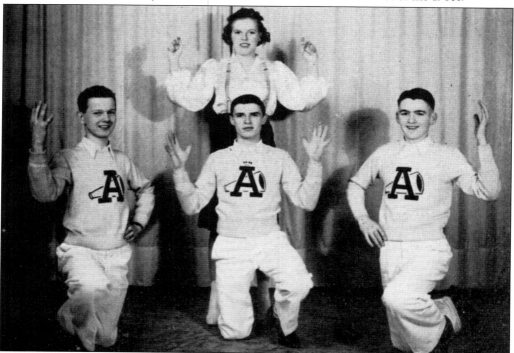

Pictured from left to right are Bill Cook, Gene Redd, Irene Schillios, and Wallie Funk, Anacortes High's "Yell Duke" in 1939. Funk's parents and grandparents were significantly involved in Anacortes history from the 1890s on. Funk edited an underground newspaper, the *Ghost Sheet*, while in school and bought the *Anacortes American* after earning a journalism degree from the University of Washington.

Eight

MARINEER'S PAGEANT

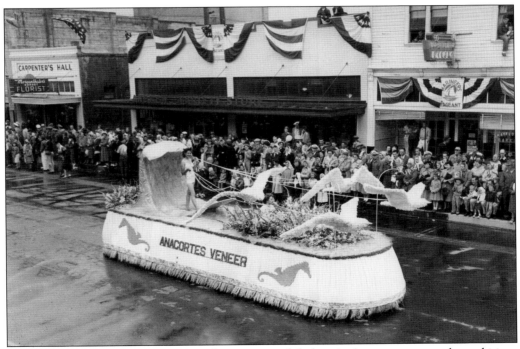

In the midst of the Great Depression, the movers and shakers in Anacortes set on the ambitious task of inventing and producing a citywide water-themed festival called the Marineer's Pageant. Beginning in 1937, the town hosted thousands of tourists who were attracted by parades, water-ski stunts, canoe races, and zany contests like the Cat Putter-Outer Derby. The Anacortes Veneer float parades northbound on Commercial Avenue in front of the Shannon Building, occupied by the Mayflower Bakery. Farther down the block are Andrews Variety Store, Morganthaler's Sunset Florist, and the Carpenters Union Hall. (Courtesy of the Anacortes Museum.)

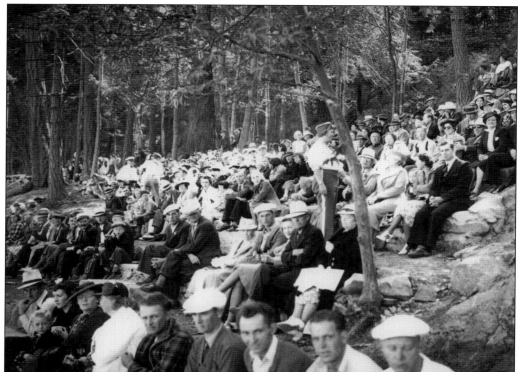

During the Great Depression, President Roosevelt created the Works Progress Administration (WPA). Its purpose was to get people working again by funding public projects in communities across the country. One of the many such projects in Anacortes was the construction in 1938 of a marine amphitheater on the east side of Cap Sante. Benches were structured of rock and held an audience of hundreds of people gathered to watch various water sports and tricks, including water-skiers pulled by airplanes. (Both photographs by Ferd Brady, courtesy of the Anacortes Museum.)

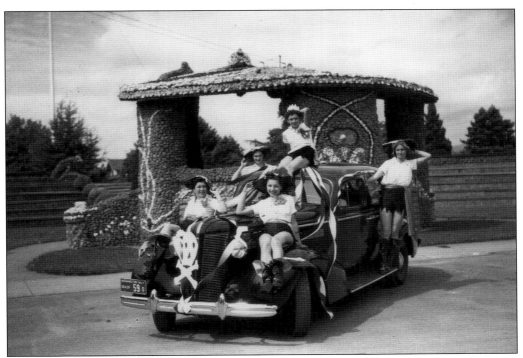

The whole town got involved in the Marineer's fun. The royalty for 1939 were LaVerne Baer, Peggy Denny, Hazel Ent, Mamie Olsen, Louella Decker, and Queen Alice Johnson posing (above, in no particular order) at Causland Park in skimpy pirate outfits. Even longshoremen's union Local 3883 (below) created a float. The pageant ran for five years of growing success until World War II suspended the festivities. It returned in 1947 and continued sporadically until 1957. (Both photographs by Ferd Brady, courtesy of the Anacortes Museum.)

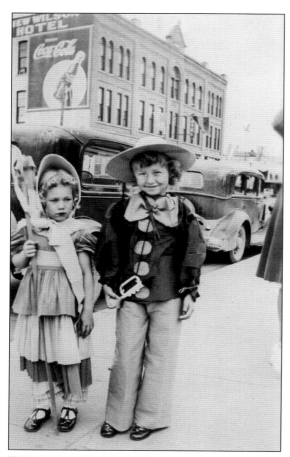

Children were encouraged to dress up and join their own part of the parade, as with Little Bo Peep and Little Boy Blue posing at left with the New Wilson Hotel in the background. Produce fills the wagon of the young gardener below, including berries, beets, onions, corn, and lettuce. (Both photographs by Ferd Brady, courtesy of the Anacortes Museum.)

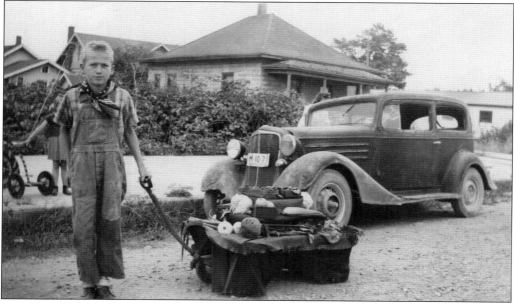

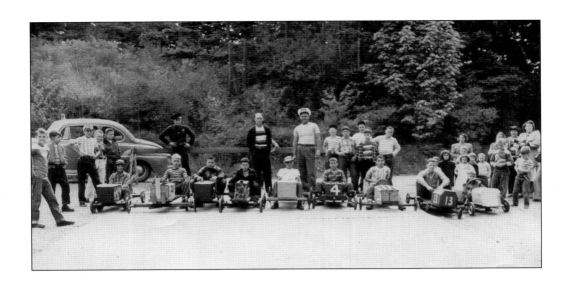

One of Irv Ryberg's (above, center with the white hat) jobs was to organize the youth activities at Marineer's Pageant, like this race between homemade carts rolling down from the top of Fourth Street on Cap Sante. Gravity did all of the work and helmets weren't yet a consideration around 1950. Boys in this 1940 bike race (below) ride past the Platt Building. Dybbro's Market is visible in the next block; it would move in the next year to a new location at Fifteenth Street and Commercial Avenue. (Above, courtesy of the Rydberg family; below, the Anacortes Museum.)

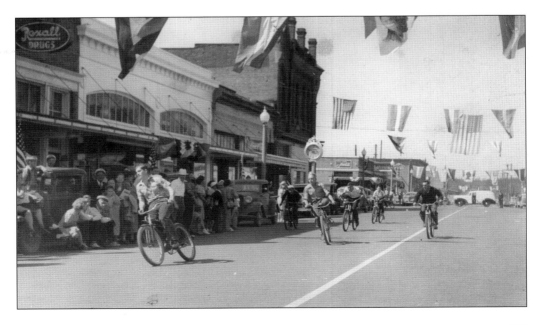

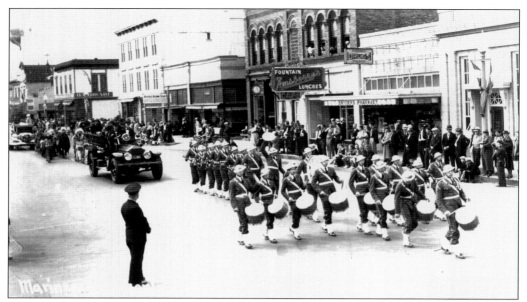

The inaugural 1937 Marineer's Pageant parade marches past the businesses on Commercial Avenue near Fifth Street; drum corps are followed by Anacortes's fire truck, with Shannon Hardware, Buster Brown Shoes, Amsberry's Café, Snyder's Pharmacy, and the Bank of Commerce behind on the west side. The pageant proved to be a success from the start but was suspended during the war years. (Photograph by Ferd Brady, courtesy of the Anacortes Museum.)

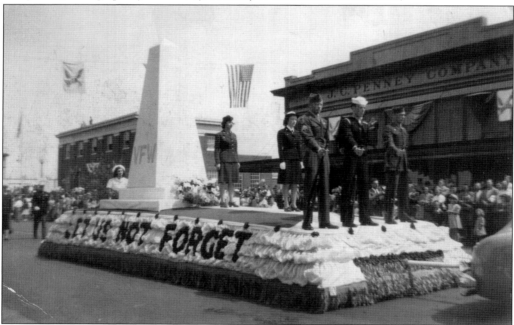

The first year of the Marineer's Pageant following World War II was 1947, and this patriotic-themed American Legion float expresses the reverence for who and what had been sacrificed. Visible behind the float is the Anacortes Post Office and the J. C. Penney store on the east side of Commercial Avenue at Sixth Street.

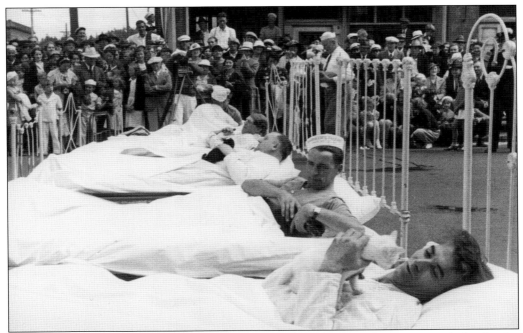

In this 1937 pageant event, the original caption reads, "In a cat-putter-outer derby for the 'championship of the world', the northwest's best compete in the city streets. Fighting a thirty mile wind they jump from bed, thrust the cat out of a door and race the 25 yards back to 'slumber'." Holding cats in bed from front to back are Ed Schwartz, Gilbert Hull, Paul Dybbro, and unidentified.

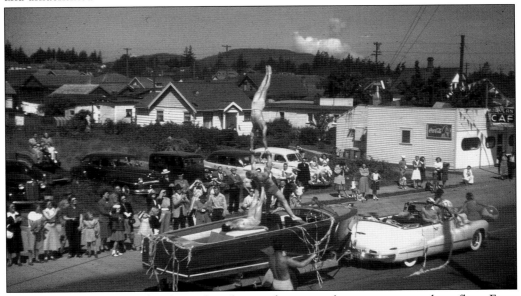

The 1948 pageant featured male acrobats forming human sculptures on a motorboat float. From the roof of Robbins Lumber at 1717 Commercial Avenue, this photograph takes in one of many vacant lots and the Steakhouse restaurant at 1712 Commercial. (Photograph by Tubby Nelson, courtesy Ann Nelson.)

Here the Anacortes Lions Club poses in front of a merry-go-round in 1937. The Lions Club is one example of Anacortes's many fraternal organizations that thrived early in the 20th century and survived into the 21st, as have the Eagles, Elks, Kiwanis, Masonic Lodge, Rotary, Soroptimists, and others. For decades, they have offered society and a means of community service to the men and women of Anacortes. (Photograph by Ferd Brady, courtesy of the Anacortes Museum.)

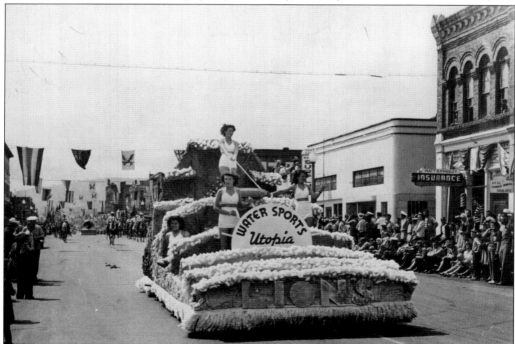

While few would deny that Anacortes is a water sports utopia, that alone couldn't keep the pageant going beyond 1957. One theory about the demise of the Marineer's Pageant is that it grew to a size that was simply too much cost and effort for Anacortes to handle. Seattle's Seafair, begun in 1950, was arguably inspired by the Anacortes festival. (Courtesy of the Anacortes Museum.)

Nine

Go Have Fun

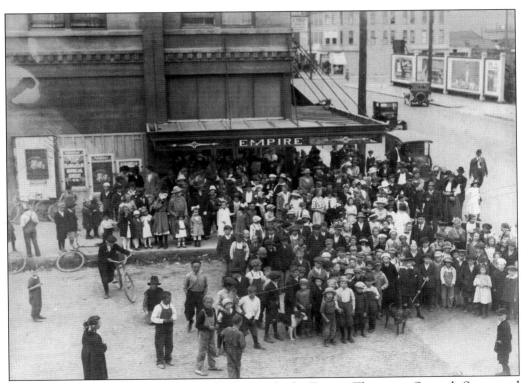

This photograph captures the mass of kids outside the Empire Theater at Seventh Street and Commercial Avenue assembled for Buster Brown Entertainment. It was taken from the second floor on the opposite corner on August 17, 1920. Billboards front the vacant lot at Sixth Street and Commercial Avenue that will eventually see a J. C. Penney store built on it in 1928. (Courtesy of the Anacortes Mural Project.)

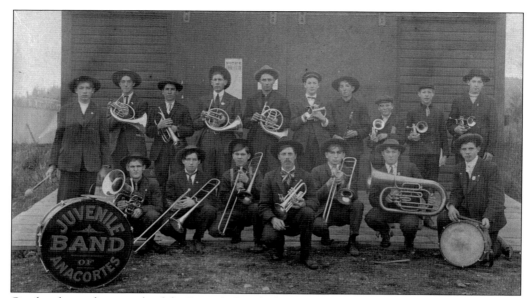

On the above photograph of the Juvenile Band of Anacortes, it is noted that Clyde Trafton has his cap on. The 1928 photograph below of the Nelson School Children's Band lists most of the children but without regard to order: Bernice Peters, Billy Latimer, Della Blackson, Elmer Burgess, Evelyn Burgess, Eugenia Gerick, Floyd ?, Florence Anderson, George ?, Harold Henry, Pauline Myron, Dorothy Silvernail, Shirley Hanson, Shirley Gorton, Novella Weaver, Stanley Richmond, Lyla Reddig, Teddy Lanphere, Betty Bannerman, Julia Dibble, Edward Milkowski, John Veloni, Lois Cummings, Marvin ?, Dick Brown, Wallace Levine, Phillip Bargewell, and Helen Carlson. (Both courtesy of the Anacortes Museum.)

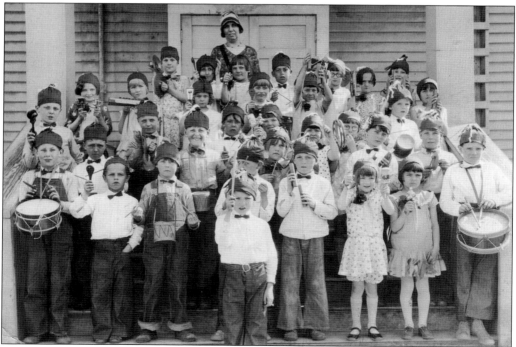

Tommy Coffelt joins Henrietta "Bubble" Blaisdell in the costume contest at a 1925 Elks masquerade ball. Local papers reported that "she represented the moon with an elaborate gown of green ornamented with pearls and an elaborate head dress." Coffelt represented the sun, and they capped first prize with a sun and moon dance.

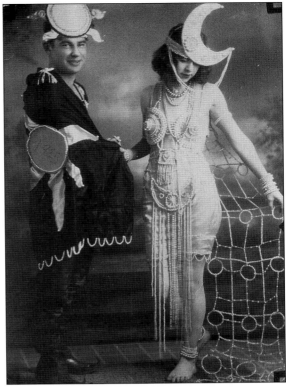

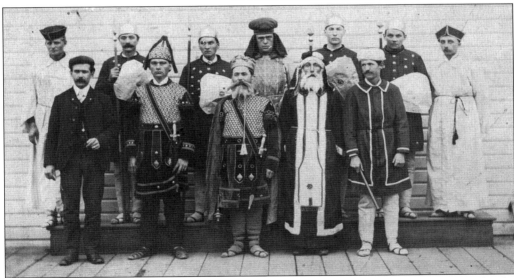

Some of the early fraternal organizations in Anacortes are distantly remembered, if at all. The Knights of the Maccabees, among the best costumed, formed in Canada in 1878 as a fraternal organization that offered insurance to its members at affordable rates. Other organizations that have faded from the local scene are the Woodsmen of the World, the Independent Order of Odd Fellows, the Townsend Club, and the Grand Army of the Republic. (Courtesy of the Anacortes Museum.)

Frank Barcott (with banjo) plays music on a porch in the Croatian neighborhood of Fifteenth Street, referred to by some as Garlic Avenue. He is accompanied by his friend Harold Schillios, whose cousin Gust Arneson operated the Lake Erie Grocery amid the Scandinavian farmers. Harold went on to perform in bands at fishermen dances. (Courtesy of the Barcott family.)

Singing the old songs at the wedding reception for Mary Suryan and Bill Houghton at the Anacortes Eagles in the late 1940s are, from left to right, Frank Barcott Sr., Catherine Barcott, Maria Dragovich, Fran Barcott, Joe Dragovich (with accordion), Betty Suryan, Peter Oreb, and Maria Jurkovich (in kitchen). (Courtesy of Fran Svornich.)

Kay Andrich dances in the early 1940s with Glen Denadel (above, the only couple both facing camera) at the Community Building at Sixth Street and Q Avenue, which became city hall and was once the Elks Ballroom. Dances were a regular form of weekend entertainment, occurring also at the Eagles Hall or Oddfellows Lodge. The Goff brothers' Serenaders (posing below) performed around Anacortes and regionally. They were favorite performers at the fishermen dances that occurred on summer weekends, sometimes as huge street dances on the pavement of Seventh Street, when Anacortes hosted hundreds of purse seine fishermen in town for the salmon season. From left to right are Bill McCallum, Glenn Strong, Bruce Goff, unidentified, Joe Dwelley, Jack Goff, Harold Schillios, and unidentified. (Above, courtesy of Kay Andrich; below, photograph by Ferd Brady, courtesy of the Anacortes Museum.)

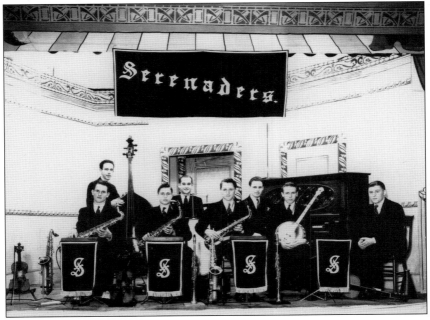

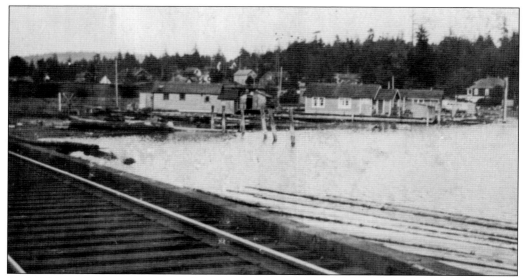

Little Chicago had a reputation as Anacortes's other side of the tracks. The residents here seemed content to enjoy waterfront living at it simplest, with shacks on logs and on pilings built right down to the north shore of the Cap Sante basin, a remnant of the early years in Anacortes seen here in a photograph from the 1920s. (Courtesy of Arnold Moe.)

The beaches in Anacortes were crowded with industry, but as long as salmon guts weren't being dumped that day, many kids swam at the Apex Beach in Guemes Channel near J Avenue. Helen Webb lived nearby and worked at the Apex Cannery as a teen. After graduating from AHS and attending college, she married boxer Mickey Hannon. Here she throws a mock punch at a workmate.

Saturday entertainment for these teenagers in the 1930s consisted of regular hikes along the beach, either at Cap Sante or the lower canneries, or by ferry over to Guemes Island. Anacortes, like most small towns, required a capacity for making one's own fun: from left to right are Vance Anderson, Patty Graham, and Willard Hammer. (Courtesy of Kay Andrich.)

Perhaps it was a more common occurrence to come upon a beached octopus a century ago. But it was the singularly creative mind of Henrietta "Bubble" Blaisdell that would attempt this intimate of a pose with the slimy creature. Far from squeamish, it demonstrates the adventuresome and provocative approach she took to art and to life.

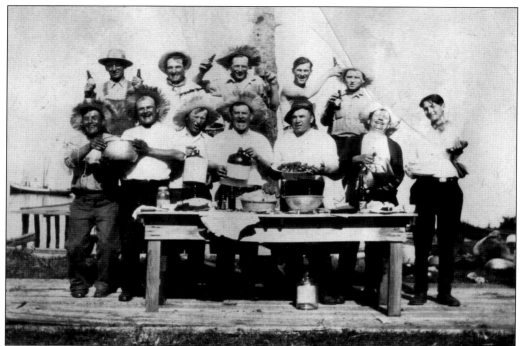

Frank Barcott loaded his purse seiner, *Cleveland*, with family, friends, and food for a picnic in the San Juans in the mid-1920s, seen above. From left to right are (first row) unidentified, Rudy Franulovich, Anton Barcott, Paul Bosnich, John Suryan, Frank Barcott, and Paul Franulovich; (second row) unidentified, Pete Oreb, unidentified, Poule Barcott, and "Chupa" Barcott. Like forests and salmon, open beaches seemed like an unlimited resource at the outset of the 20th century. Either by walking down the street or boating to a secluded island, a day at the beach was always close at hand. These Croatian fishermen's wives, seen below, noticed profoundly colder water than that of the Adriatic Sea of their homeland; from left to right are unidentified, Maria Oreb, Bata ?, Jaka Barcott, Klema Bosnich, Kata Franulovich, Vica Andrich, and Maria Barcott. (Both courtesy of the Barcott family.)

These Guemes Island kids are dressed in Dutch costumes for a folk dance performance. Future mayor Bud Strom and future ballet star Gordon Sholwalter are among the troupe, which also included Earl Blackinton, Kathaleen Hayden, Leonard Penter, Olive Strom, Alma Zehner, and Sean Williamson. (Courtesy of the Anacortes Museum.)

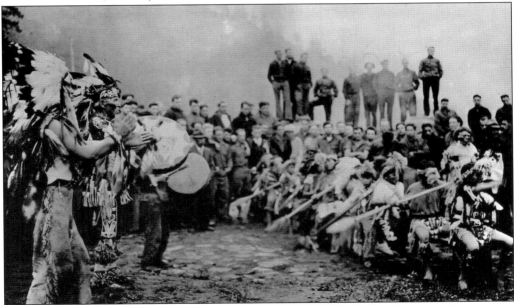

Dancers from the Lummi Indian Nation perform one of their dances for the boys of the Civilian Conservation Corps at Deception Pass State Park in 1934. Performances like these carried on tribal traditions and caught the interest of young ethnographers like Harry Smith and Bill Holm. (Photograph by John Tursi, courtesy of the Anacortes Museum.)

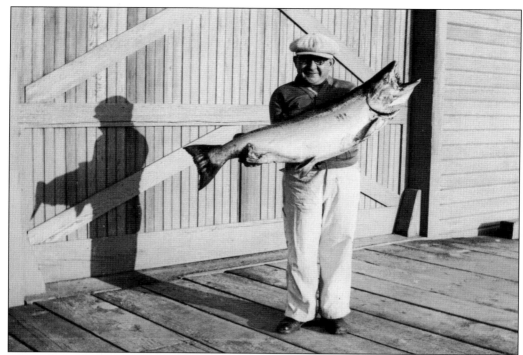

Fritz Rydberg holds a prize-winning king salmon caught in the 1940s. Fritz was the son of Scandinavian immigrants who came to Anacortes in the boom days of the 1890s. For 40 years, between 1912 and 1952, he worked as cook on the stern-wheel snag boat *W. T. Preston*, which is now a maritime museum in Anacortes, located at 713 R Avenue. (Courtesy of the Anacortes Museum.)

These winners of the 1937 salmon derby are, from left to right (starting with the woman in white), Alice Johnson, Dr. Lyle Packard, Arnold Houle, Walter Mercer, Pete Thayer, Ed Erholm, R. A. Bechaud, Jennie LeMaister, Dr. S. G. Brooks, Bette Brown, Dr. Virgil Rose, and E. G. Childs. (Photograph by Ferd Brady, courtesy of the Anacortes Museum.)

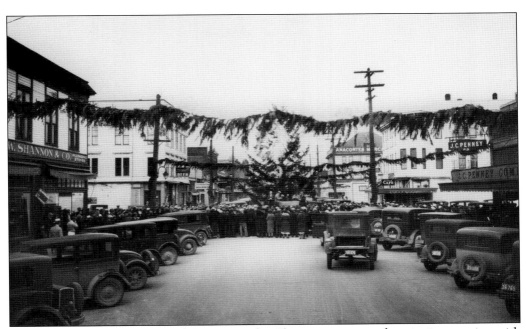

Cedar boughs span Commercial Avenue, and a Christmas tree stands at its intersection with Sixth Street. A crowd is gathered for a gift drawing, like one of many promotions organized by Paul Luvera and the chamber of commerce. Seen to the left is Shannon Hardware in its fourth decade of business. Across the street is an early chain store, the local J. C. Penney, which opened in 1928. (Photograph by Ferd Brady, courtesy of the Anacortes Museum.)

Throughout the Depression, people were hungry for food and cheap entertainment. Paul Luvera's (at cash register) solution was to add entertainment value to shopping for necessity. Entry for weekly prize drawings came with grocery purchase. Necessities and little luxuries were offered and always drew a crowd. (Courtesy of Phyllis Ennes.)

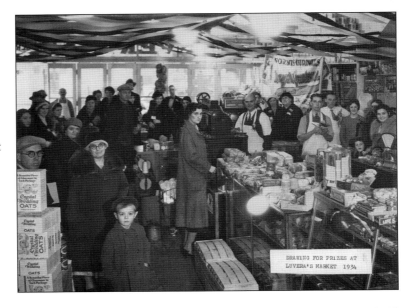

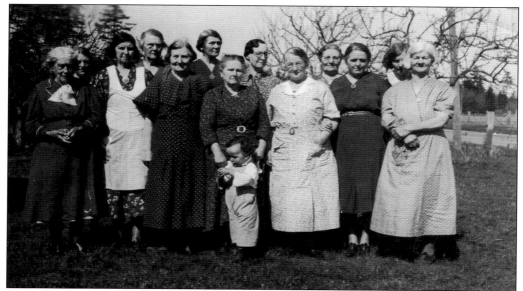

Several farms were established just south of Anacortes near Whistle Lake, a city water source. These neighborhood women gathered informally as the Whistle Lake Club. From left to right are Mrs. Helfi, Edith Lowder, Mrs. Burkhart, Mrs. Anderson, Mrs. Burton, May Kast, Katie Smith, Lucy Kast, Effie Lydie, Mrs. Bob Knapp, Mrs. McClean, Mrs. Lyman, and Mrs. Kavanaugh. (Courtesy of the Anacortes Museum.)

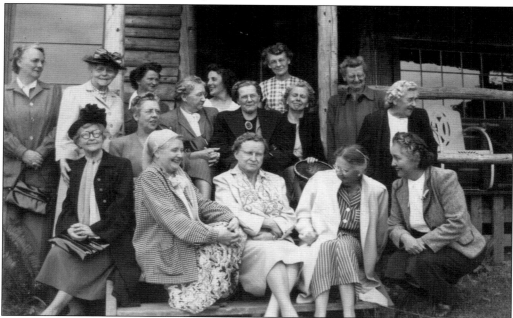

The Women's Business and Professional Club formed in 1934 with a goal of equal opportunity and equal pay for women everywhere. They helped pay for the community building, supported music in the schools, offered awards for the outstanding girl in school debate, and entertained all graduating girls at an annual breakfast. Margaret McNary, editor of the *Anacortes Mercury*, sits at the front left wearing a black hat. (Courtesy of the Anacortes Museum.)

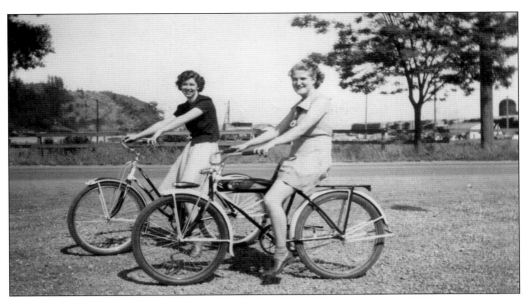

Kay Handy (left) and Ellen Lundberg rented bikes for this outing on a late-1930s summer day. In the background at right is the Morrison Mill smokestack and Cap Sante taken from near Twelfth Street and Commercial Avenue. Note the railing across the street that prevented pedestrians from falling off into a large marsh between Commercial and Q Avenues. Ellen's father, Gus, owned the purse seiner *Liberty*. (Courtesy of Kay Andrich.)

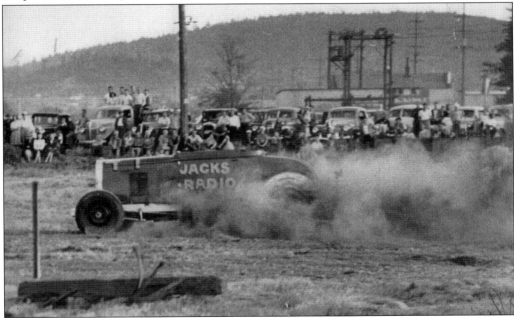

Charlie Overton rounds the south turn in his car sponsored by Jack's Radio. Anacortes had its own racetrack, immediately east of Commercial Avenue between Eleventh and Thirteenth Streets, in a marsh that dried out enough each summer for racing to occur. The site also served as a location for visiting carnivals and community bonfires until being filled in the 1970s. (Courtesy of the Anacortes Museum.)

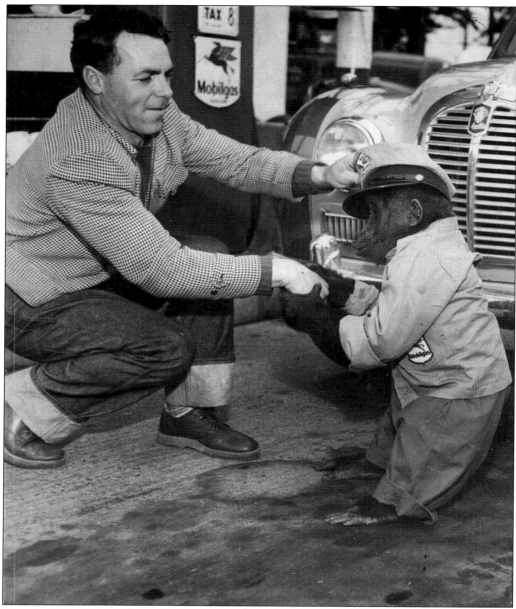

Brought to town by Bill Lowman in 1951, Bobo quickly became the most popular resident of Anacortes. This baby gorilla lived with Bill's parents, eating at the family table and sleeping in his own bed, until his size and strength led the family to place him at Woodland Park Zoo in Seattle. Bill Lowman spent his life working on the water as a commercial fisherman out of Anacortes. (Courtesy of the Anacortes Mural Project.)

Bobo is in the loving arms of Jean Lowman, his surrogate mother, who raised the gorilla in the family home on Eighth Street from early infancy. Jean's son Bill bought Bobo in 1951 after a lucrative season in commercial fishing. To protect Bobo from human diseases (he once caught the chicken pox), the family was compelled to place a notice in the local paper requesting limits on drop-in visits. (Courtesy of the Anacortes Mural Project.)

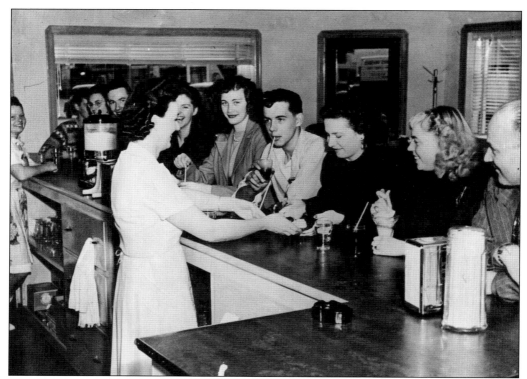

The West Coast Creamery processed local eggs and milk for bottled delivery and cream and butter production, operating from the Semar Building at Fifth Street and Q Avenue from the 1920s into the 1950s. Young and old lined the counter for treats at the creamery's ice cream parlor. (Courtesy of the Anacortes Museum.)

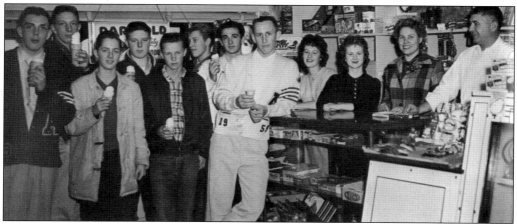

What began as the High School Store, an unpretentious structure built in the 1920s on the corner of Seventeenth Street and K Avenue, became known as the Seahawk Store, operated by the Atterberry family for the better part of five decades.

Ten

ALL-AMERICAN CITY

Ralph Handy grew up in Bayview, across Fidalgo Bay from Anacortes, as it boomed and busted in the early 1890s. He raised his family in Anacortes, clerked at Anacortes Hardware in the 1920s (see page 29), and, as a retirement job, worked as a custodian for the school district. Pictured here in the Columbian School belfry, Handy tends to the bell that has become a symbol of school spirit at Anacortes High since the Columbian's demolition in 1966. (Courtesy of Kay Andrich.)

More than 1,200 Anacortes citizens participated in a 17-week study during 1953, inspired by Dr. Poston's book *Democracy Is You*, ultimately issuing a five-volume study, "Anacortes In Action," that investigated the whole town's perspective on the needs and potential paths toward an ideal Anacortes. Glee Malland is pictured here, making the survey rounds near Cap Sante. (Courtesy of Wallie Funk.)

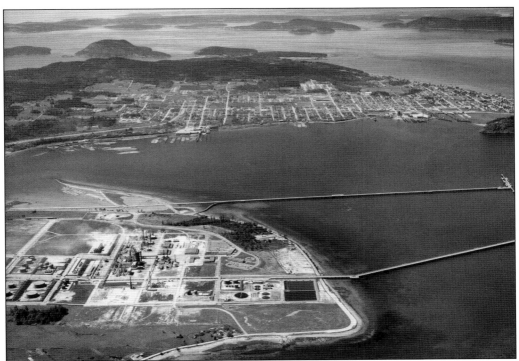

While Anacortes townspeople were discussing the city's future, land on March Point was being quietly acquired by Shell Oil as a site for a refinery (above), which promised to fill gaps in the economy left by the closure of several mills. The arrival of Shell in 1953 and Texaco in 1957 created jobs for locals and brought in a wave of newcomers to the community. The Bechtel office workers (below) from left to right are Jessie ?, Lillian Johnson, Gwen Brown, Emma ?, Mary ?, Dorothy Quall, Jessie ?, Betty Atie, Darlene ?, Lucille ?, Margaret ?, Clarise ?, LaVerne Rydberg, Dorothy Bartholomew, Elsie ?, Marie Keats, Joan Dagg, M. Whitney, and Inez Lassus. (Both courtesy of the Rydberg family.)

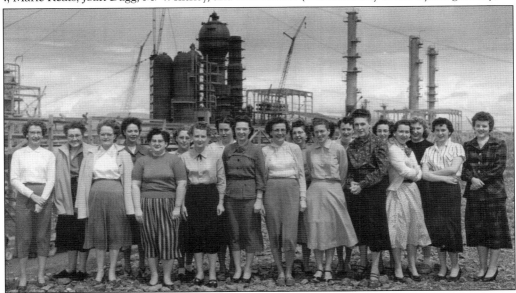

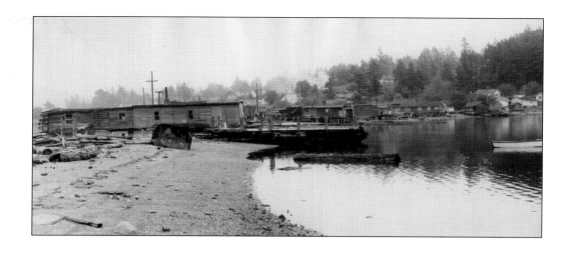

As part of an "urban renewal" program, whole neighborhoods were leveled, like Little Chicago (above), which was razed in the mid-1950s (below). Later dozens of homes were condemned on Fidalgo Bay around the defunct mills. Anacortes's self-improvement process created a sense of constructive engagement that at times challenged the community's past identities. New schools replaced old, gravel streets were paved, and flood-prone creeks were routed into underground pipes. (Photographs by Wallie Funk.)

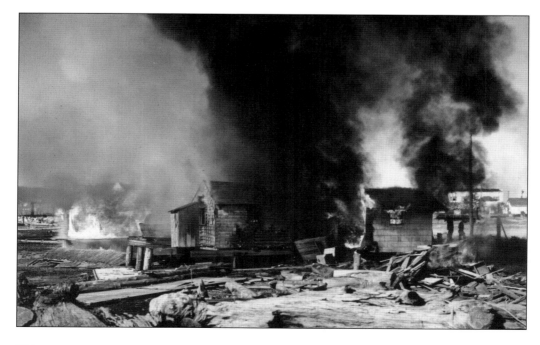

While patterns of the past were fading or being purposefully destroyed, new opportunities were presented to many. Dave Kelley, seen here, grew up in Little Chicago and went on after high school to make a career at the Shell refinery. A vital marine industry would eventually grow where the neighborhood on Fidalgo Bay once stood. Preservation and progress are still being negotiated in Anacortes. (Courtesy of Ardith Kelley.)

Despite growth and development pressures, Anacortes has demonstrated a commitment to nature unequalled in few if any other cities, preserving more than 2,800 acres of community forestland and many other parks. Thankfully little has changed at Heart Lake since this 1890 photograph was taken. Some of the same trees still stand, now over 500 years old, under the shadow of Mount Erie on Heart Lake's south shore. (Photograph by D. B. Ewing, courtesy of the Anacortes Museum.)

Amos Bowman's (left) *Northwest Enterprise* promoted his vision of a metropolis on Fidalgo Island. At the time of Bowman's death in 1894, his dreams appeared to have failed. Yet in the decades that followed, and because of the achievements made throughout the 1950s, Anacortes was recognized as an "All America City" by the National Municipal League and *Look Magazine* in 1962. The movers and shakers (below) in this accomplishment are raising the flag in Causland Park; from left to right are Paul Luvera, Wallie Funk, Bud Strom, Jerry Mansfield, Madge Stafford, and Scott Richards.

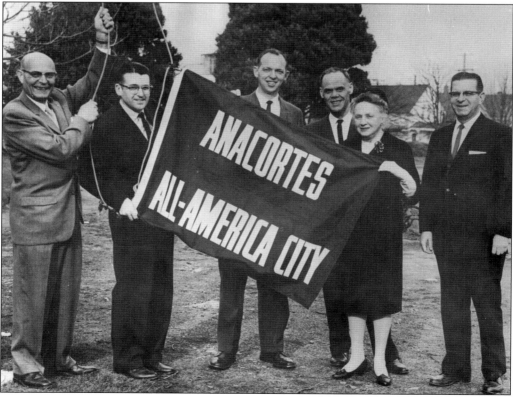

BIBLIOGRAPHY

"Anacortes In Action," Anacortes Community Study, 1953–1954.

Carey, Betty Lowman. *Bijaboji*. Madeira Park, BC, Canada: Harbour Publishing, 2004.

DeLong, Harriet Tracy. *Pacific Schooner Wawona*. Bellevue, WA: Documentary Book Publishers Corporation, 1985.

Ennes, Phyllis. *From the End of 9th Street*. Anacortes, WA: Charlie's Chapbooks, 2006.

Gunther, Erna and Haeberlin, Hermann. *The Indians of Puget Sound*. Seattle: University of Washington Press, 1930.

Hansen, Kenneth. *The Maiden of Deception Pass*. Anacortes, WA: Samish Experience Productions, 1983.

Jones-Lamb, Karen. *Native American Wives of San Juan Settlers*. Decatur, WA: Ben Tirion Publishing, 1994.

"Our Century." *Anacortes American*, January 2000.

Rands, Agnes. *Even Seagulls Cry*. Sisters, OR: Linden Press, 2005.

Rhododendron. Anacortes, WA: Anacortes High School, 1922–1960.

Sampson, Chief Martin. *Indians of Skagit County*. Mount Vernon, WA: Skagit County Historical Society, 1972.

Slotemaker, Terry. *Fidalgo Fishing*. Anacortes, WA: Anacortes Museum, 2005.

———. *From Logs to Lumber*. Anacortes, WA: Anacortes Museum, 2007.

Trebon, Theresa. *First Views, An Early History of Skagit County: 1850–1899*. Mount Vernon, WA: Skagit Valley Herald, 2002.

Tursi, John and Thelma Palmer. *Long Journey to the Rose Garden*. Anacortes, WA: Fidalgo Bay Publishing, 1989.

Willis, Margaret, ed. *Chechacos All, The Pioneering of Skagit*. Mount Vernon, WA: Skagit County Historical Society, 1973.

———. *Skagit Settlers, Trials and Triumphs, 1890–1920*. Mount Vernon, WA: Skagit County Historical Society, 1975.

Wollam, Dan, ed. *The Anacortes Story*. Anacortes, WA: Anacortes Museum of History and Art, 1965.

Discover Thousands of Local History Books
Featuring Millions of Vintage Images

Arcadia Publishing, the leading local history publisher in the United States, is committed to making history accessible and meaningful through publishing books that celebrate and preserve the heritage of America's people and places.

Find more books like this at
www.arcadiapublishing.com

Search for your hometown history, your old stomping grounds, and even your favorite sports team.